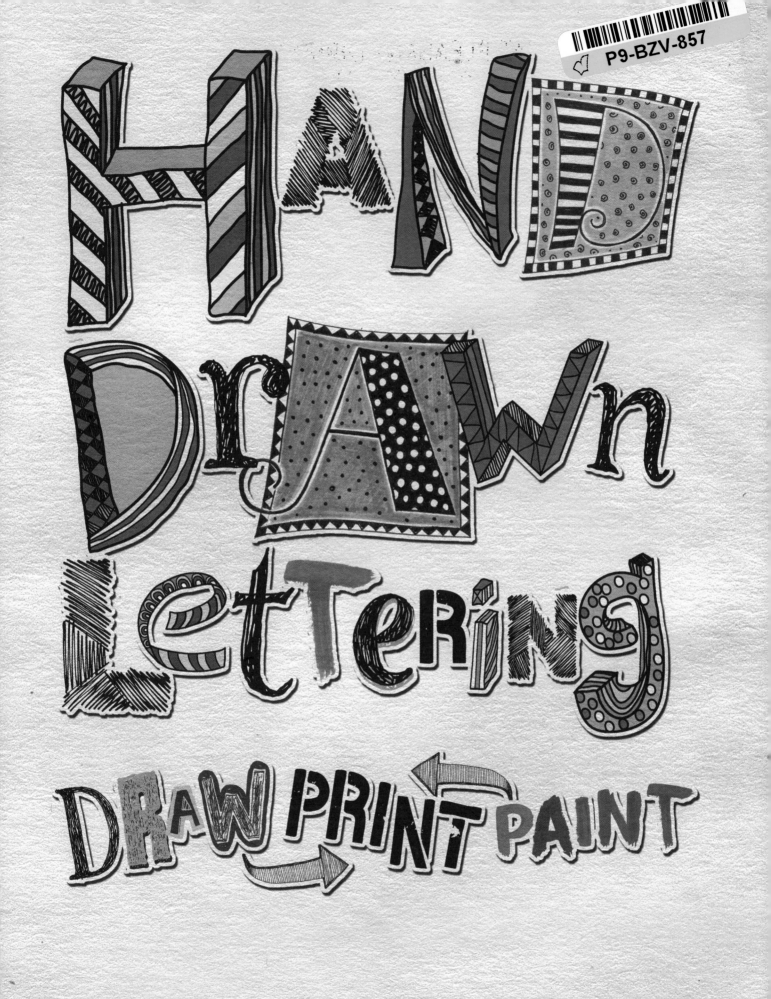

# HAND DrAwn LeTTeriNG

## DRAW PRINT PAINT

First edition for North America and the
Philippines published in 2016 by Barron's
Educational Series, Inc.

First published in Great Britain in 2016 by
Book House
An imprint of The Salariya Book Company Ltd
25 Marlborough Place, Brighton BN1 1UB

*All inquiries should be addressed to:*
Barron's Educational Series, Inc.
250 Wireless Boulevard
Hauppauge, NY 11788
**www.barronseduc.com**

ISBN: 978-1-4380-0831-8

Library of Congress Control No.: 2015942372

Manufactured by CP Printing Ltd., Heyuan,
Guangdong Province, China

Printed in China

9 8 7 6 5 4 3 2 1

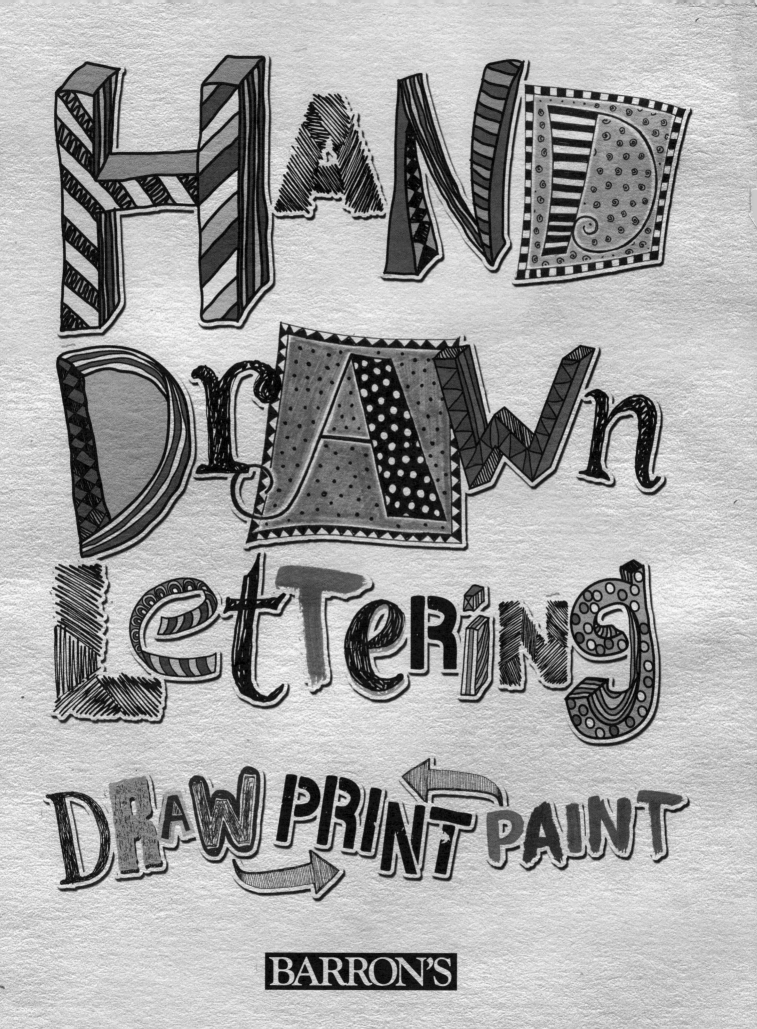

# Contents

## Chapter V  80

# Handmade

## Chapter VI  100

# Printing

## Chapter VII  110

# Inspiration

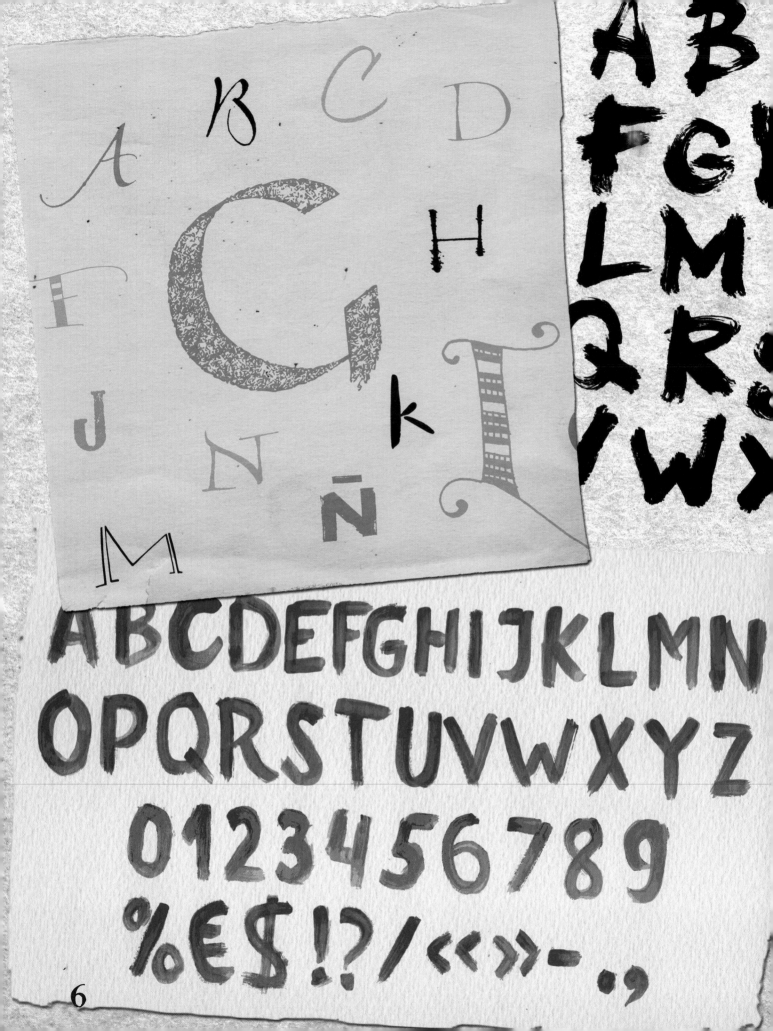

A B C D
E F G H
I J K
L Ñ
M

A B C D E F G H I J K L M N
O P Q R S T U V W X Y Z
0 1 2 3 4 5 6 7 8 9
% € $ ! ? / << >> — .,;

A B
F G
L M
Q R
W

ABCDEFG abcdefg
HIJKLMN hijklmn
OPQRSTU opqrstu
VWXYZ vwxyz
1234567890
?!+-&@$%*)

# Introduction

**H**and lettering is the art of drawing and painting letters; it is not typography or calligraphy. Calligraphy is based on penmanship and the art of writing letters.

Before the 15th century, all books were written out by hand. Monks could spend a lifetime working on a single book so books were very rare and expensive. The invention of printing by those men who pioneered movable type and printing presses: William Caxton (c. 1422–1492), Johannes Gutenberg (c. 1398–1468), and Nicolas Jenson (1404–1480) changed everything. Printed books could be produced quickly and reached many more people. So ideas spread, literacy levels increased, and the "publishing industry" was invented.

The mechanization of typesetting revolutionized the printing process. With the advent of computers, the design printing process was revolutionized yet again. Designers could have any letter shape they required. This of course meant that anyone with a computer could select a typeface and a font size. Rediscovering hand lettering can create results that are thoroughly unique and individual. The art techniques and lettering in this book are shown in simple step-by-step stages to set you off on a journey of alphabetic creativity.

## Serif:
### Times New Roman

ABCDEF
GHIJKLM
NOPQRST
UVWXYZ
abcdefghij
klmnopqrs
tuvwxyz

## Sans-serif:
### Helvetica

ABCDEF
GHIJKLM
NOPQRST
UVWXYZ
abcdefghij
klmnopqrs
tuvwxyz
123456789

# Anatomy of a font

In typography, a sans-serif is a letter that does not have the small projecting features called "serifs" at the end of each stroke. The term comes from the French word "sans" meaning "without" and the Dutch word "schreef" meaning "line."

## Sans-serif

The rediscovery of classical ruins in the 18th century influenced the style of letter design. Sir John Soane's use of sans-serif letters on his architectural drawings influenced designers.

Thought to have been
devised to neaten up
letters carved in stone,
the serif is the small
end-stroke or flourish.

Serif

# Understanding letterforms

**U**nderstanding letterforms is only really necessary when hand drawing letters that are based on traditional typefaces.

1. **Bold** is a font weight. The letters are thicker and darker than standard text. Words or letters in a bold font will stand out. (fig. A.)

2. **Italic** letters slope slightly to the right. (fig. B.)

3. **Chunky** is a modern term that refers to letters that are short and thick. (fig. C.)

4. **Cursive** letters are written in a calligraphic flowing handwriting style. (fig. D.)

5. **Downstrokes** are formed as the pen moves from the top to the bottom of a letter. Traditionally, in calligraphy, more pressure is applied to the downstroke to make it thicker. (fig. E.)

6. **Uppercase** means capital letters. The capitals were stored in the upper compartments of the printers' cases, hence their name. (fig. F.)

7. **Lowercase** refers to the small letters in a typeface, which were kept in the lower sections of the type cases. (fig. G.)

8. **Leading** is the amount of space between each line of text. It is usually measured from the base of the word below it. (fig. H.)

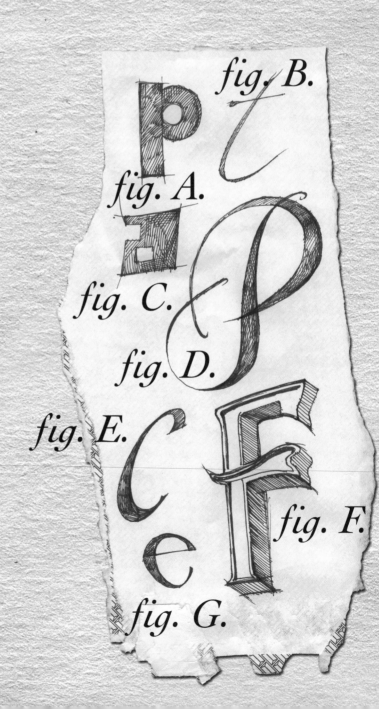

*fig. A.*

*fig. B.*

*fig. C.*

*fig. D.*

*fig. E.*

*fig. F.*

*fig. G.*

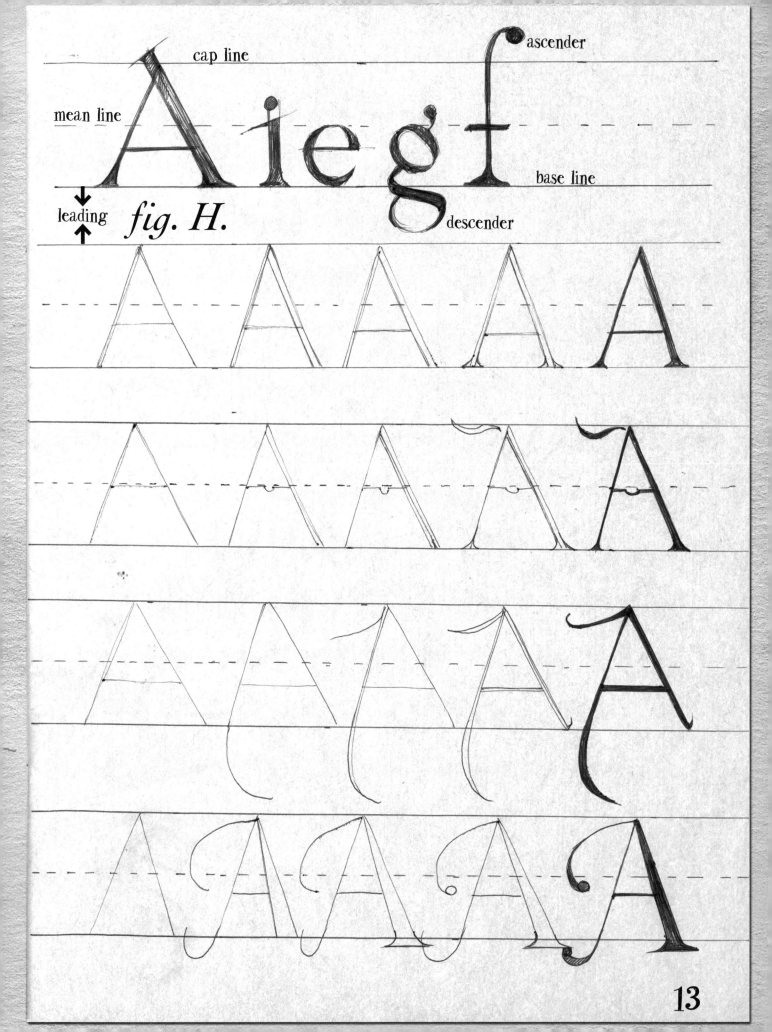

cap line

mean line

ascender

Aiegf

base line

leading

fig. H.

descender

13

# Materials

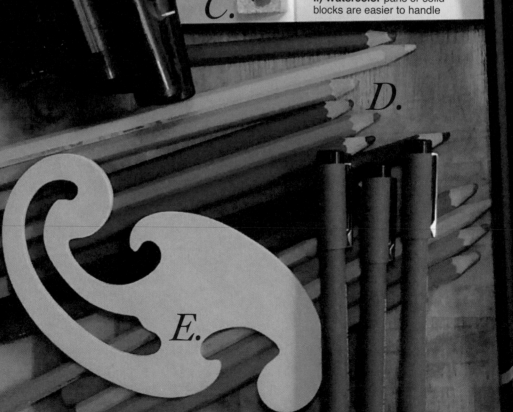

**A.) Cartridge ink pens** with oblique nibs are available in fine, medium, and broad widths.

**B.) Water-based fiber-tipped pens**. For use on many surfaces.

**C.) Manual sharpener** for all pencils. Alternatively, use a sandpaper block or craft knife.

**D.) Colored pencils** are available in a broad spectrum of colors. Water soluble versions can also be used to create a watercolor painting effect.

**E.) French curves,** made of metal, wood, or plastic come in a variety of shapes. Used to connect curving shapes.

**F.) Pencils** come in many different grades. The HB or 2B are standard sketching pencils. Choose pencils to suit your style and preference.

**G.) Flexible curve** is an adjustable device to create shaped curves of any size.

**H.) Paint brushes** are available in many shapes and sizes and are suitable for a wide range of media. They are made from synthetic fibers or natural hair as in squirrel or sable brushes.

**I.) Watercolor** pans or solid blocks are easier to handle

because they are laid out in a paint box. However, many painters prefer working from tubes. Watercolor sticks or markers are now available,

**J.) Felt-tip pens** (or fiber-tops) may have ergonomica designed triangular barrels f ease of use. Some inks are water-based—check the manufacturer's label.

**K.) Templates** are stencils, patterns, or overlays used t draw letters, shapes, or des This is a circle template.

**L.) Art masking fluid** can b used with watercolors or ink Masking fluid allows you to freely over masked areas, r than having to paint around each shape.

**M.) Wax crayons** can also water soluble.

**Other materials:**
Eraser, scissors, masking tape, ink, drawing board, tracing paper, graph paper

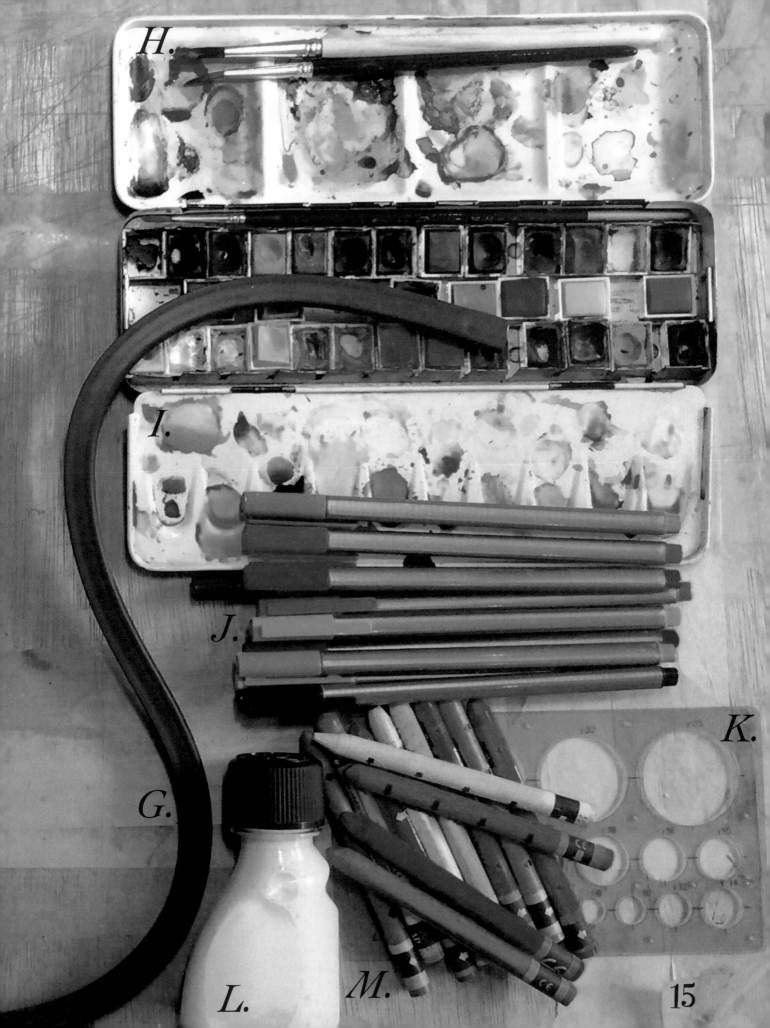

H.

I.

J.

G.

K.

L.

M.

15

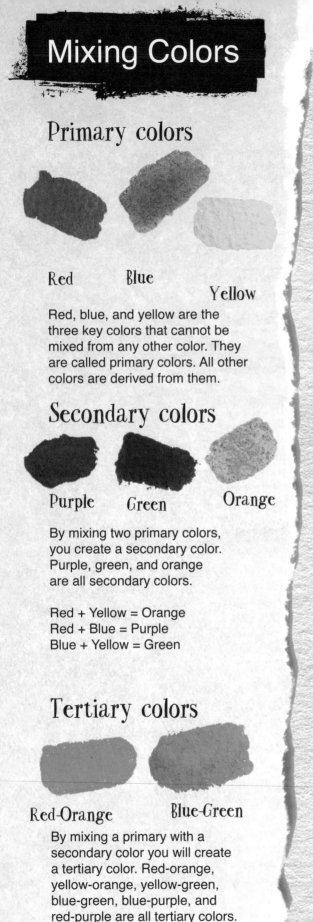

## Mixing Colors

### Primary colors

Red    Blue    Yellow

Red, blue, and yellow are the three key colors that cannot be mixed from any other color. They are called primary colors. All other colors are derived from them.

### Secondary colors

Purple    Green    Orange

By mixing two primary colors, you create a secondary color. Purple, green, and orange are all secondary colors.

Red + Yellow = Orange
Red + Blue = Purple
Blue + Yellow = Green

### Tertiary colors

Red-Orange    Blue-Green

By mixing a primary with a secondary color you will create a tertiary color. Red-orange, yellow-orange, yellow-green, blue-green, blue-purple, and red-purple are all tertiary colors.

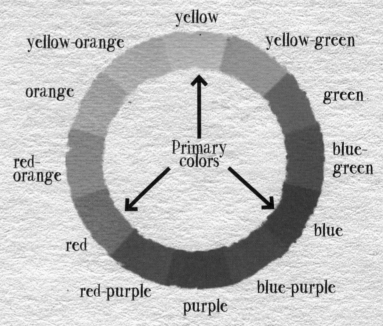

# Color

The color wheel is a circular diagram that shows the relationship between primary, secondary, and tertiary colors. All colors have a temperature—some colors look warm and some look cool. The color wheel is a helpful device for understanding color and color mixing.

## Complementary colors

Red and green are complementary colors as are orange and blue. They lie opposite each other on the color wheel (above). Placed side by side, they create vibrant, clashing color schemes.

17

## Watercolor paper

Watercolor paper comes in three different surfaces:
Rough
Hot-pressed (HP),
Cold-pressed (NOT).

## Rough paper

Rough watercolor paper has the most textured surface. When a wash is applied to this paper, the paint collects randomly in the heavily indented texture. This creates a grainy, speckled effect.

## Hot-pressed paper

Hot-pressed watercolor paper has a very smooth surface with no texture. This smooth surface is achieved by pushing the paper through hot cylinders. This type of paper is good for fine detail. It doesn't absorb water as quickly as cold-pressed paper, so allows more time to rework the paint. It is ideal for large washes.

## Cold-pressed paper

Cold-pressed watercolor paper has a slight texture which holds the pigment well. This paper is a good choice for most painters. It provides enough texture and is easier to use than rough papers.

# Paper history

Before paper was invented, people used different kinds of materials to write on. The Sumerians used clay tablets for writing by indenting marks into soft clay. Clay tablets were easy to make and fitted into the palm of the hand but were heavy to carry.

The ancient Egyptians wrote on stone, wood, and papyrus. The pulp of the papyrus plant was first pounded into strips. It was then woven together to form a sheet that was left to dry in the sun.

The invention of paper was first reported to the Chinese Emperor in AD 105. This paper was made by soaking rags or mulberry leaves in water. The water was then squeezed out, and the paper was left to dry on bamboo frames. The Chinese kept their papermaking process secret until AD 751, when some of their papermakers were captured by an Arab army. In the Middle Ages, monks wrote on parchment made from animal skins.

# CHAPTER II
# HISTORICAL

MNOP
QRSTU
VWXYZ

## Materials

- Wooden chopstick
- Art masking fluid
- Sharp blade or knife
- Ink
- Wide flat paintbrush
- Watercolor paper (HP)

*fig. A.*

## Technique

**Create a cuneiform style alphabet:**

1. Shave the chopstick to a 45-degree angle on both sides. Now pour a small amount of masking fluid into a dish.

2. Dip the shaped chopstick into the masking fluid.(fig. A.) Draw the shape of each letter with masking fluid and allow to dry. (fig. B.)

3. Paint over your alphabet with ink and allow to dry thoroughly. (fig. C.)

6. Now peel or rub off the masking fluid to reveal a cuneiform style alphabet. (fig. D.)

# The first writing

The first written language was developed by the Sumerian people of Mesopotamia around 3000 BCE. The Sumerians used reed tools to impress picture signs into clay. Over time, these signs were simplified to become groups of wedge-shaped marks. This style of script is called "cuneiform" which means "wedge shaped" in Latin.

*fig. B.*

*fig. C.*

A B C D E F G
H I J K L M N
O P Q R S T
U V W X Y
Z

*fig. D.*

A A

Cuneiform-inspired letters

# Symbols

Pictograph of Ox head

Drawing of Ox head

Many letters began as "pictographs"—pictorial symbols for a word or phrase. The ancient Semitic language, a family of ancient languages originating in the Middle East that includes Arcadian, Arabic, Aramaic, Ethiopian, Hebrew, and Phoenician, drew an ox head to represent the letter "A." Turn the modern letter "A" upside down, and you can see some of its original shape.

K ‡ A Rotated

1000 BCE. Phoenician   Ancient Greek Alpha

By 1000 BCE the Phoenicians are using the "Ox" pictograph on its side and it looks more like the letter "K." The ancient Greeks reversed it and called it "alpha," the first letter in their alphabet. Between 750 and 500 BCE the ancient Greeks rotated it to an upright position.

Writing in capital letters was very slow so scholars had to develop a style of writing which could be used on wax tablets with a stylus. The small letter "a" that we know today is based on handwriting from the last days of the Roman empire at the time of the Emperor Charlemagne.

# The first letters

Why write things down? Because no one can remember everything. Each time a story is told, the details are likely to change. And two people seeing the same event might remember it differently. But once written down, a story cannot change.

The first written signs were pictures of everyday objects. But realistic pictures take time to draw. So they became simplified and more like symbols. To show more complicated concepts like "hunger" or "slowly," writers invented other symbols. Later, new signs were developed to represent sounds in language. These signs or letters could be strung together to spell words.

ɑ a a a

This sequence shows the development of a lowercase "a" from the time of Charlemagne to the primary school "a" used today.

A  B  C  D

E  F  G  H

I  J  K  L

M  N  O/U  P

R  S  T  X

Y  Z

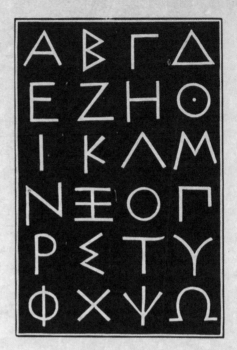

Greek letters from a stele (inscribed column) in Athens 394 BCE. A set of letters is called an alphabet. The word alphabet comes from *alpha* and *beta*, the first two letters in the Greek alphabet.

AABCCDE
FGEFGHIL
MLMLMN
MNOPPP
QRRSTRR
STVXVXY

The way of writing letters in the Roman alphabet has barely changed over the last 2,000 years.

Each hieroglyph in the ancient Egyptian alphabet represented one sound. Words could be spelled out or represented by a single drawing. Q, V, and W were not used.

## Materials

- Water soluble wax pastels
- Watercolor paper (HP)
- Pencil
- Colored pencils or
  felt-tip pens

Practice on scrap paper or layout paper. Steps 1 and 2 (below) can be used as a template for all your letters to keep a continuity of scale.

## Technique

1. Draw a square. (fig. A.)

2. Draw a vertical and horizontal line to cross through the center of the square. (fig. B.)

3. Draw circles as shown. Draw in the shape of the letter. (fig. C.)

4. Color in the letter shape. (fig. D.)

# Constructed capitals

**A**lbrecht Dürer was born in Nuremberg, Germany, in 1471. He was a printmaker, painter, and engraver. He published four books on geometry, one of which was on typography. This book showed how the ancient Roman alphabet could be constructed using geometric measurements.

*fig. A.*

*fig. B.*

*fig. C.*

*fig. D.*

The ancient Roman alphabet, formed in capitals, was a truly Roman invention and was not borrowed from the Greeks. This alphabet has formed the basis of Western writing and printing. These "monumental capitals" were designed to be carved by stonemasons so their geometric structure was drawn with a ruler and compasses.

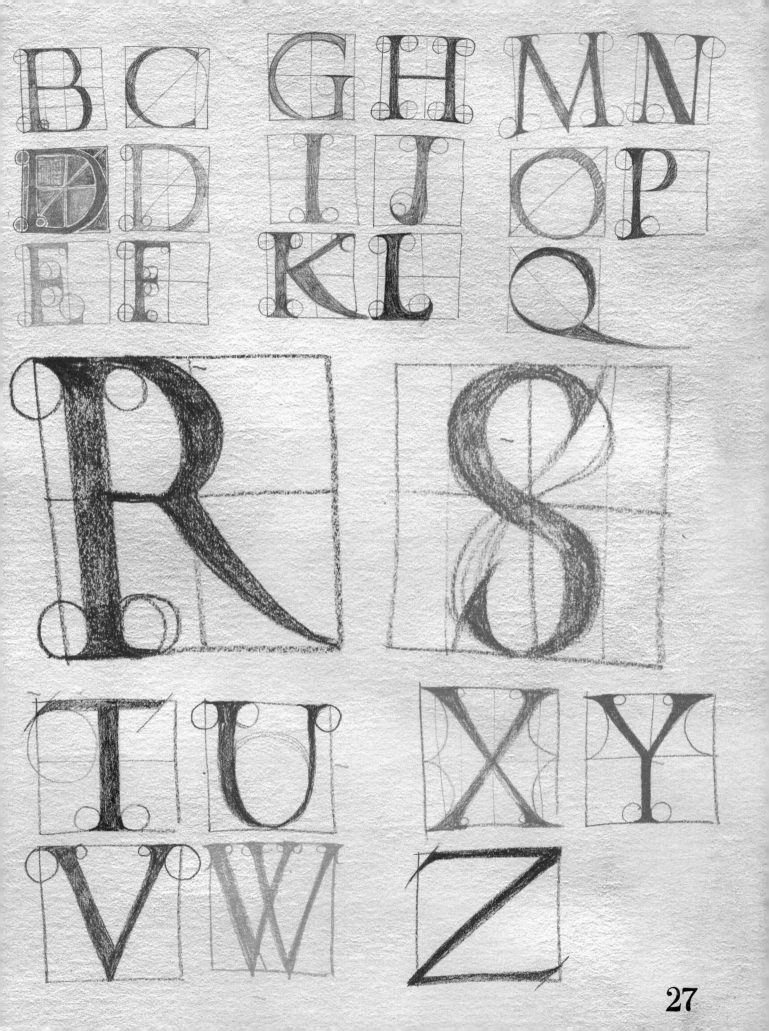

## Materials

- Water soluble wax pastels
- Watercolor paper (HP)
- Paintbrush
- Watercolor paint

## Technique

Letters in the constructed alphabet can be given many different finishes.

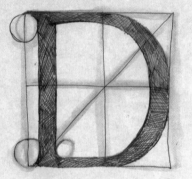

Infilled by cross-hatching with a black ballpoint pen.

Using a colored pencil over the watercolor base gives the letter added definition.

Black felt-tip combined with watercolor construction lines.

# Watercolor alphabet

In Albrecht Dürer's book, *Of the Just Shaping of Letters,* he gives specific instructions on the formation of each letter. Each one occupies a square and is constructed with geometric exercises using a compass and a straightedge. Drawing this font in freehand gives scope for individual flair and expression.

*fig. A.*

*fig. B.*

*fig. C.*

*fig. D.*

Try creating your own watercolor alphabet based on the constructed alphabet designed by Albrecht Dürer. Follow the instructions on page 26; then use a paintbrush and watercolor paint to create the lettering. Change the water between colors to keep each color pure.

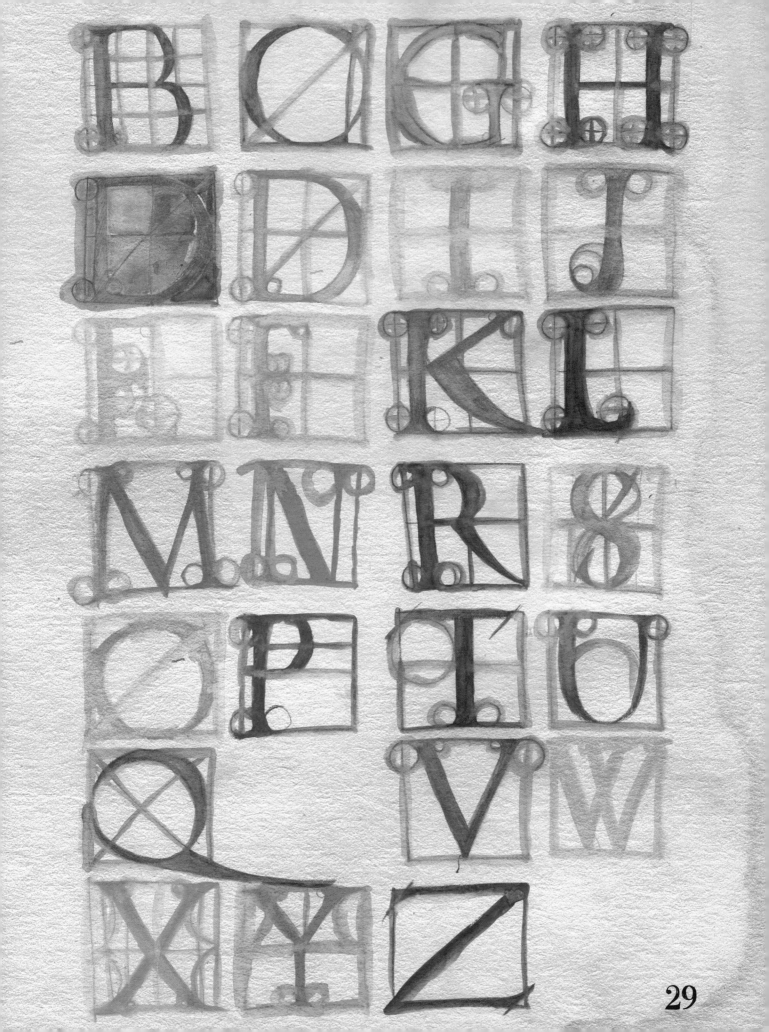

# Manuscripts

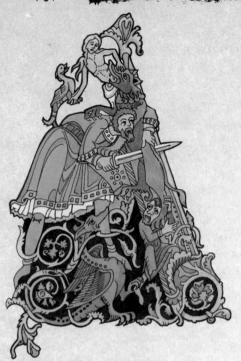

This capital "A" comes from a manuscript made in England between 1120 and 1140. It shows a knight with animals.

The writing of manuscripts and bookmaking in medieval Europe was dominated by the Christian Church. Before printing was invented, all books had to be copied out by hand. Monks dedicated their lives to the painstaking task of making beautiful bibles and prayer books. These are called illuminated manuscripts, because the pages included burnished silver and gold decoration. The monk would divide each page into blocks of text with gridlines. Once the text had been copied, the page would be completed with a large decorative capital letter. Church services were conducted in Latin, so the monks would read and write in Latin, too.

Monks could spend 20 to 30 years copying out one book. To overcome their boredom, they often added little poems or drawings.

This book belonged to the English monk Saint Boniface, who died in AD 754. Legend says that it was slashed when non-believers tried to murder him.

# Anglo-Saxon

AbCDEF

MNOPQRS

TUWXYZ

These 18 letters from the Anglo-Saxon alphabet date from the early Middle Ages, nearly a thousand years ago. This alphabet has only 24 letters, two less than today's alphabet.

## Materials

- Pencil
- Paper

## Technique

1. Always start constructing a letter with a frame. (fig. A.)

2. Add weight and shape to the frame. Check its overall shape and symmetry. (fig. B.)

3. Block in the shape of the letter. (fig. C.)

# Drawing letters

Try tracing letterforms so you can get used to the shapes they make. Learn where lines become thicker or thinner and where emphasis is being stressed. Always sketch out your lettering lightly in pencil first to establish the correct spacing. By placing the letters accurately you will not run out of space and each letter will complement those alongside it.

*fig. A.*

*fig. B.*

*fig. C.*

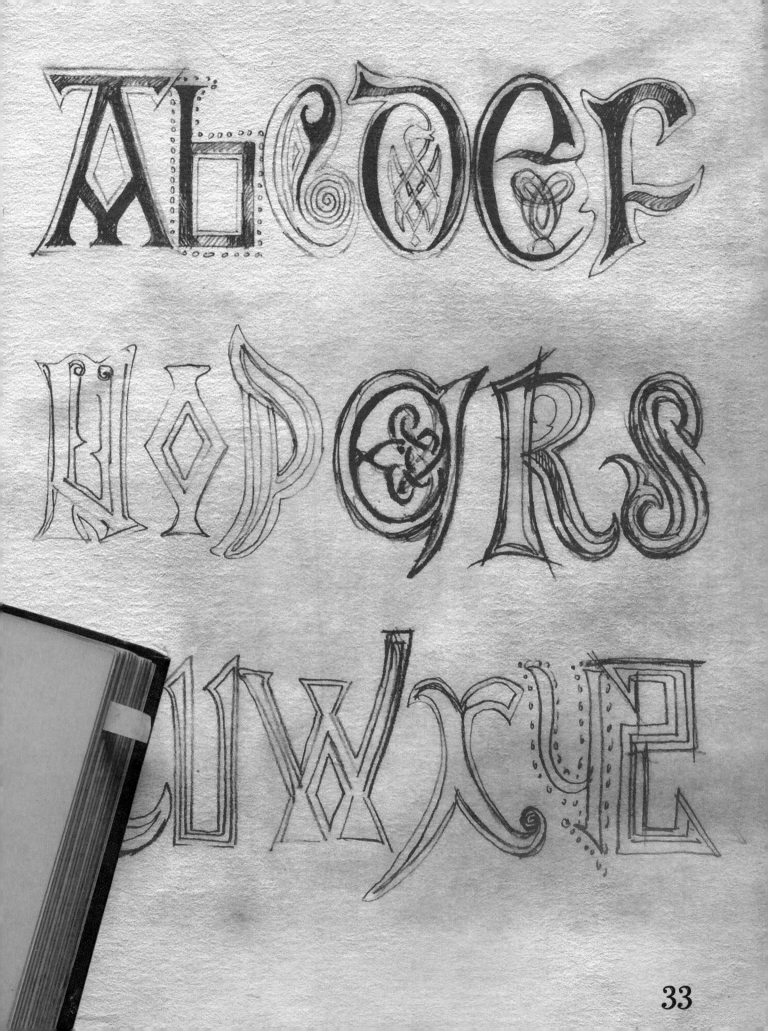

33

Gutenberg was born in Germany around 1400. He may have started printing around 1439. By 1450 he set up a printing workshop. His first printed book was probably the Mazarin bible.

To print, Gutenberg had to design a typeface—a set of letters that would look good together in any order. He came up with Gothic or German script. Each individual letter was made in reverse for printing. Otherwise the words would print back to front.

# Printing press

The invention of printing was a huge step forward that changed history. A method of printing with wooden blocks was invented in China in the 800s. A similar method, using metal type, was perfected much later in Europe by Johannes Gutenberg around 1440. Individual letters made of lead could be lined up to form words and blocks of text. These were covered in ink and printed onto sheets of paper in a machine called a printing press. Each letter could be cleaned and reused. A printing press could print thousands of pages a day. For the first time, ordinary people could afford to read—or even write—their own books. Learning spread far and wide as a result.

◀ A typefounder holding a mould as he pours molten metal into it. Each letter needed its own mould.

▶ The word "Gothic" was first used to describe this letter style in Renaissance Italy in the 15th century. Italian classical scholars described the style as "barbaric."

# Gothic-style letters

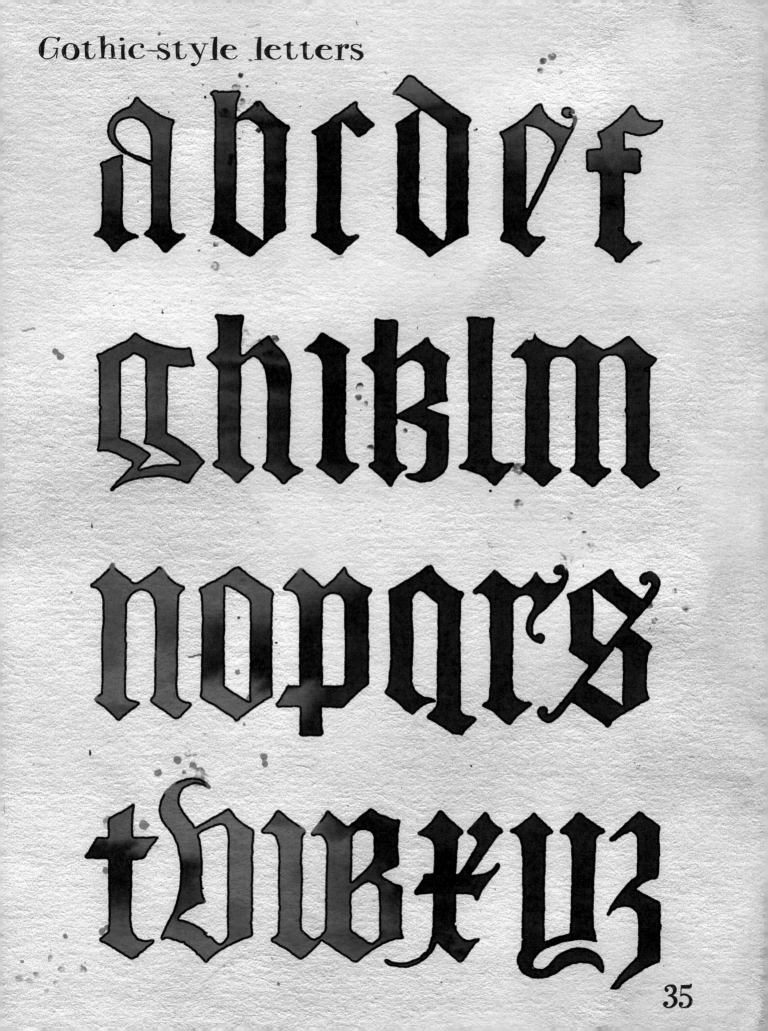

abcdef

ghiklm

nopqrs

thwxyz

35

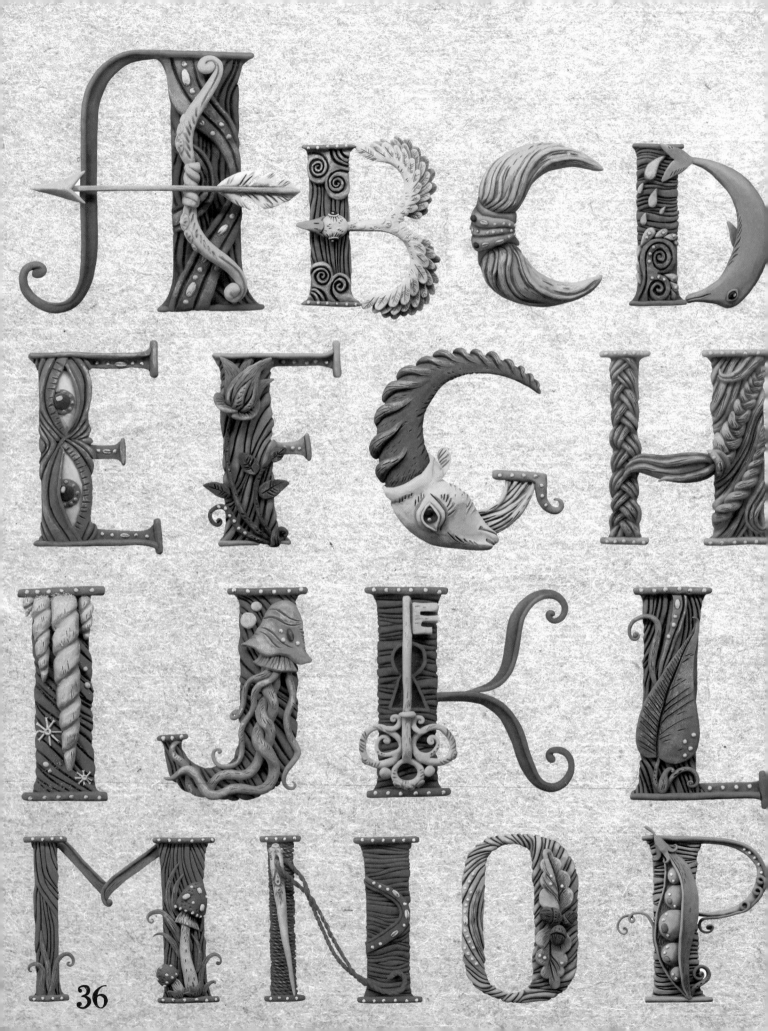

# WHIMSICAL

## Materials

• Colored pencils
• Watercolor paper (HP)

Slowly build up the color in layers to achieve a greater tonal range. Think about the direction of the pencil marks you are making to keep them consistent.

## Technique

1. To draw the letter "A," start by drawing its top line only. (fig. A.)

2. From the center of this line draw two lines for the upright. (fig. B.)

3. Color in. (fig. C.)

4. Complete the letter shape (as shown) and color in. (fig. D.)

These letter examples were drawn "freehand." If a more accurate result is desired, compasses and a ruler can be used.

# Colored pencil alphabet

Colored pencils can produce a speedy result. Build up layers of color as required to create a variation in tone. They can be used on a variety of papers, but consider the tooth of the paper as this will affect the finished result. If a very smooth result is required, place some smooth card under your paper.

*fig. A.*

*fig. B.*

*fig. C.*

*fig. D.*

Lightly pencil in the rough shape of each letter, and then sketch in the stages above. It is important to consider the shape, spacing, and style of each letter when writing out a word.

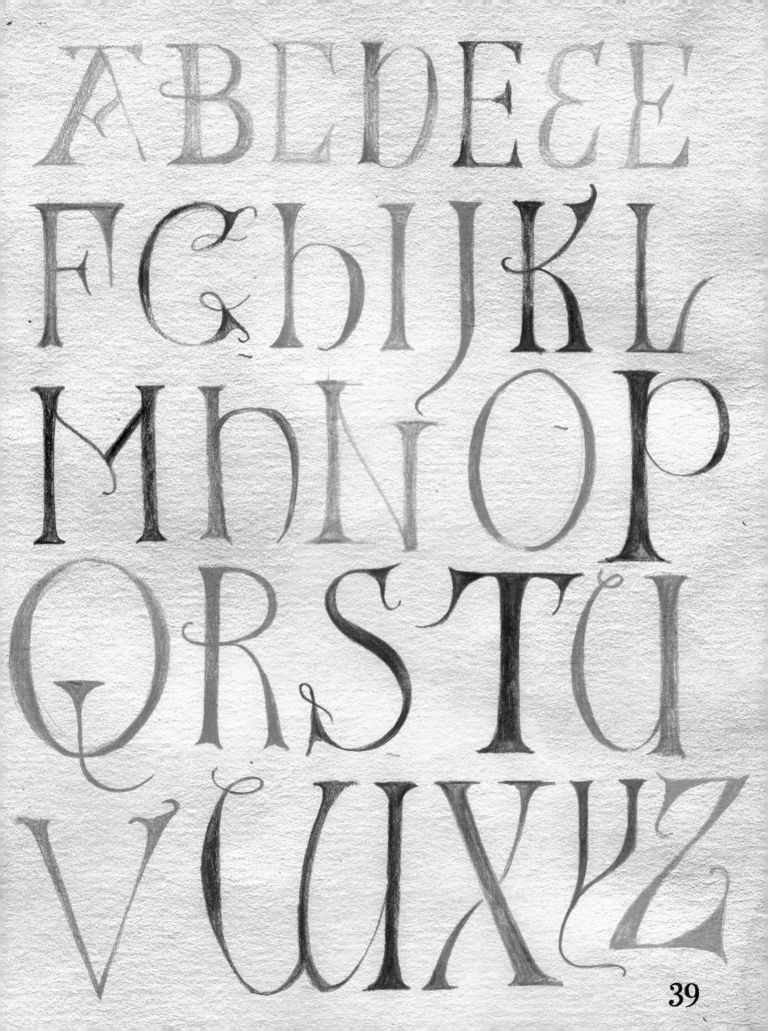

39

## Materials

- Fountain pen with an oblique nib
- Watercolor paper (HP)
- Pencil
- Colored inks

Practice on any scrap paper, or use layout paper. Make a basic template to ensure the letters are drawn to the same scale: draw a square in black line to slip under the paper as a guide.

## Technique

1. Lightly pencil in the shape of the letter S. (fig. A.)

2. Draw in the outlines of the letter. (fig. B.)

3. Draw in the additional decorative "spikes," and ink in the outline. Vary the line width to give emphasis to parts of the letter. (fig. C.)

4. Work from the outline adding small short strokes. Try to create slightly wedge-shaped marks. (fig. D.)

# Inky alphabet

This alphabet was created using a fountain pen with an oblique nib. Ink made especially for fountain pens does not contain any solid matter, which means that the ink will flow evenly. Ink cartridges are readily available, are easy to change, and come in a range of exciting colors.

*fig. A.*          *fig. B.*

*fig. C.*          *fig. D.*

Drawing ink can be "waterproof" or "non-waterproof." Dip-pens generally work well with non-waterproof inks. This combination is mostly used for letter writing, calligraphy, and artwork. Waterproof ink is not recommended for fountain pens or most technical drawing pens. Transparent inks usually flow faster from the nib than opaque inks.

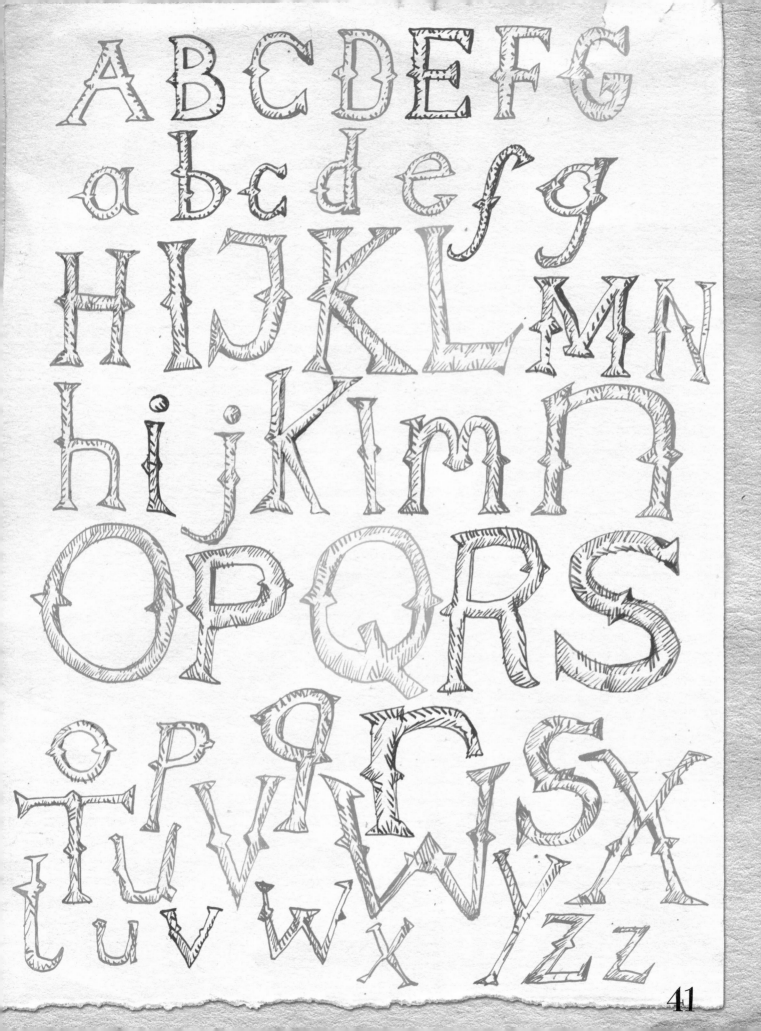

41

## Materials

- Pencil
- Layout paper (or any thin paper)
- Watercolor paper (HP)
- Black fineliner pen
- Watercolor paint
- Gold paint
- Paint brush

## Technique

1. Lightly pencil in the rough shape of each letter then add a frame. (fig. A.)

2. Sketch in all the letters of the alphabet to create a whole "family" of related letter shapes. (fig. B.)

3. Use a sharp pencil to define the shape of each letter, and add decoration and color to its frame. (fig. C.)

4. Draw over the pencil lines with the fineliner pen. Remove unwanted pencil lines with an eraser.

# Drawing letters

Drawing complex letters may seem daunting at first, but by studying the construction of a letter you can break it down into simpler shapes. Layout paper is a thin paper that is good for sketching out ideas, but any kind of thin paper can be used.

## fig. A.

Graphite pencils are available in different grades. Hard pencils are grayer and range from H to 6H. Soft pencils are blacker and range from B to 9B. Experiment to find which pencils you like best.

# Whimsical illuminated lettering
## fig. B.

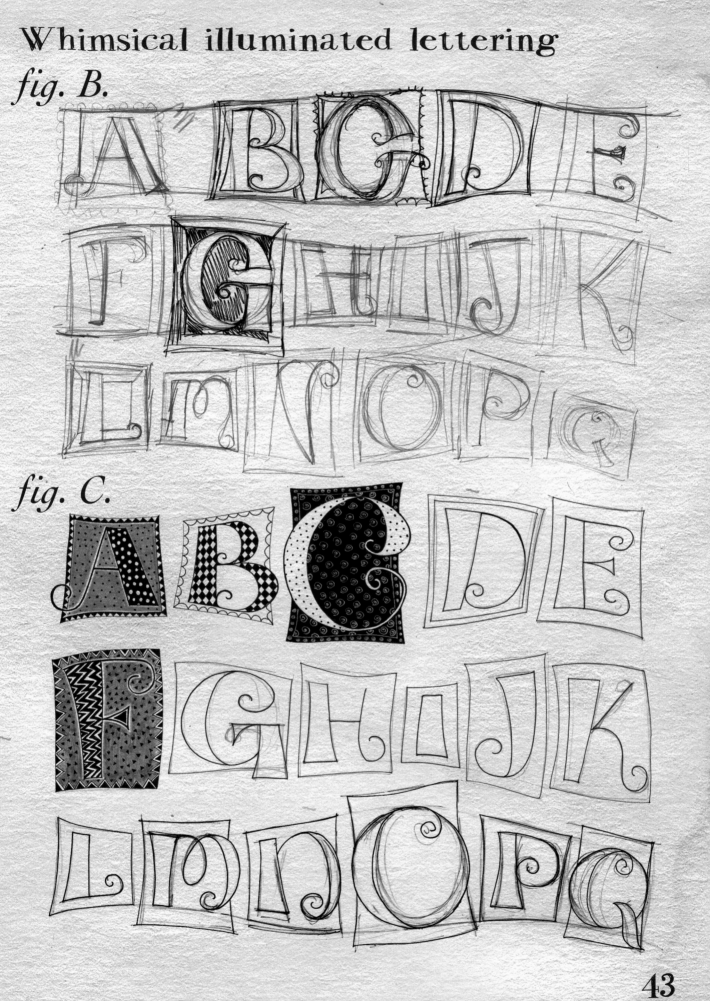

## fig. C.

### Technique

1. When mixing watercolor paint, remember to mix the dominant color onto your palette first (with water). Add small amounts of other colors to it. (fig. A.)

2. Use a limited palette of color. The letters of the alphabet (opposite) have been painted with black, yellow, gray, and gold. A limited color palette helps make words more legible. (fig. B.)

3. First decide on a light source direction. Then add shading to the far parts of each letter to make it look as though the letter is raised up. Maintain a consistent light source throughout. (fig. C.)

4. Try using a white fineliner pen on top of dark colors to create a reversed effect with white cross-hatching. (fig. D.)

# Painting letters

U se watercolors to paint your letters. Watercolor paper comes in different thicknesses and weights—choose a slightly thicker paper (300 gsm or over) to prevent the paper warping when it's wet. Hot-pressed watercolor paper has a very smooth surface so it is ideal for drawing as well as painting.

*fig. A.*

Light source

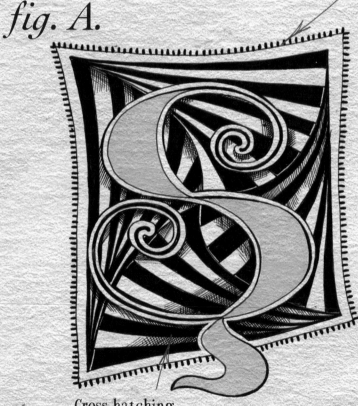

Cross-hatching

Adding pencil shading on top of the black lines will create a 3D look. Decide on your light source before you start. Begin with an area of hatching; then slowly build up using the pencil in different directions. (This is easier to do if you swivel the paper as you work.)

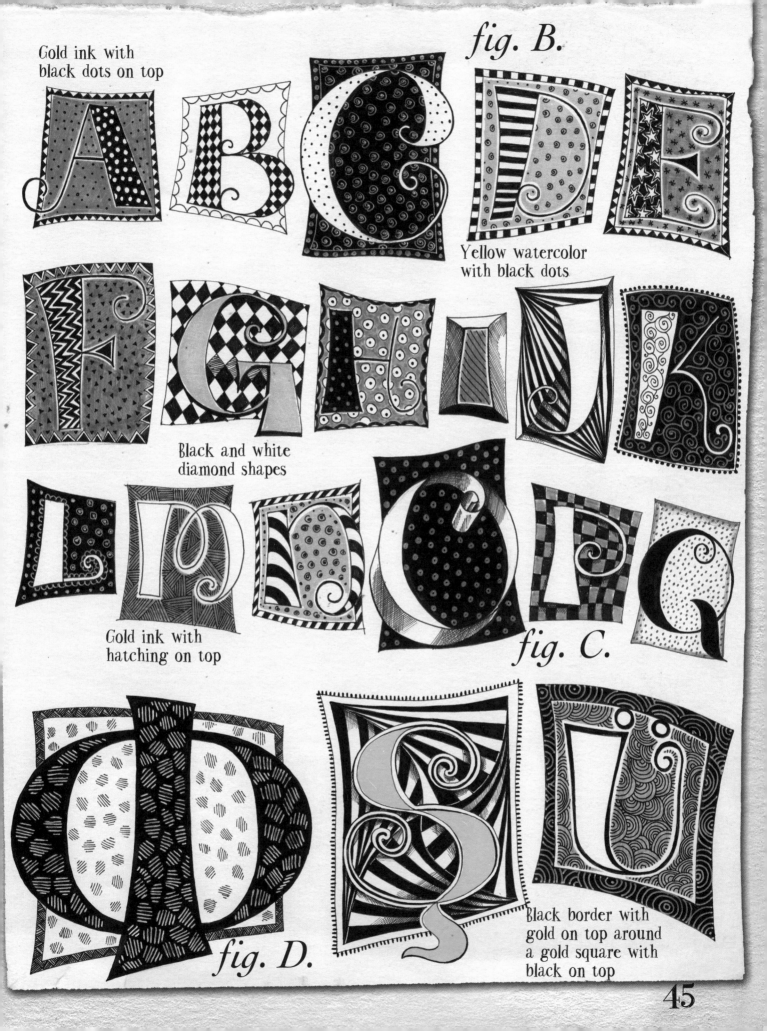

Gold ink with black dots on top

*fig. B.*

Yellow watercolor with black dots

Black and white diamond shapes

Gold ink with hatching on top

*fig. C.*

*fig. D.*

Black border with gold on top around a gold square with black on top

45

# Make some art

Inspiration strikes at the oddest moments, so keep a sketchbook to squirrel away ideas as they occur to you. Let your mind and pencil wander. In this way, you can incorporate random ideas into later projects. A sketchbook allows you to chart the evolution of your ideas from initial spark to finished art. It's fascinating to see how an idea progresses.

## Make your own sketchbook

## Materials

- 4 x A1 sheets of paper
- Glue
- Awl (a metal pointed tool)
- Card for covers and spine
- Linen strip
- Needle and thread
- Craft knife

Sketchbooks come in a vast array of sizes and types of paper. Making your own sketchbook allows you to choose the size, format, and paper that best suits you. You can make sketchbooks from scrap paper or your preferred drawing paper.

Keeping a daily sketchbook to scribble and jot down ideas will make you think creatively. Remember that a sketchbook is highly personal—there is no right or wrong way to use one. Loose drawings can always go astray. A sketchbook keeps all your drawings and ideas together.

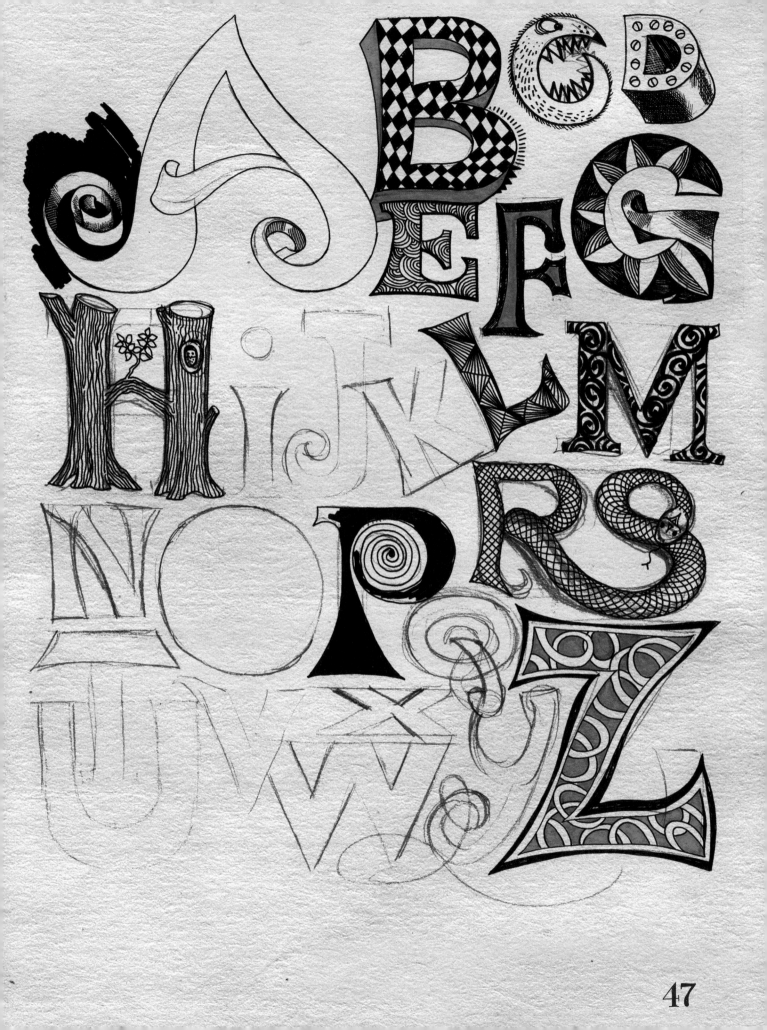

47

# Sketchbooks

### Technique

1. Fold each of the 4 A1 sheets of paper in half, four times (sixteen equal sections).

2. Place the folded sections together vertically. Make four evenly spaced holes along the left-hand side. Use a large needle or awl.

3. Start to sew the sections together.

4. Once the left-hand edges are sewn together firmly, trim the remaining uncut edges to form pages. Use a craft knife or scissors.

5. Cut the card to form front and back covers and a spine. Glue the spine to the sewn sections. Allow to dry. Glue on the covers. Place a weight on top, and allow to dry.

6. Bind the spine and covers together. Cut a linen strip (the length of the spine and 3 times its width). Glue the strip to the center of the spine and around each cover. Decorate to complete, if required.

Four sheets of A1 paper will make an A6 sketchbook with 64 pages if both sides are used.
A1 paper size: 84.1 x 59.4 cm (33.1 x 23.4 in)
A6 paper size: 14.8 x 10.5 cm (5.8 x 4.1 in)

A brand-new sketchbook can be intimidating and can dampen your creativity. Its pristine pages can make you feel that every mark made must be precious and perfect. A sketchbook needs to be inexpensive so that you feel free to be messy and creative in any way you wish.

Beautiful sketchbooks like these can be a hindrance to creativity.

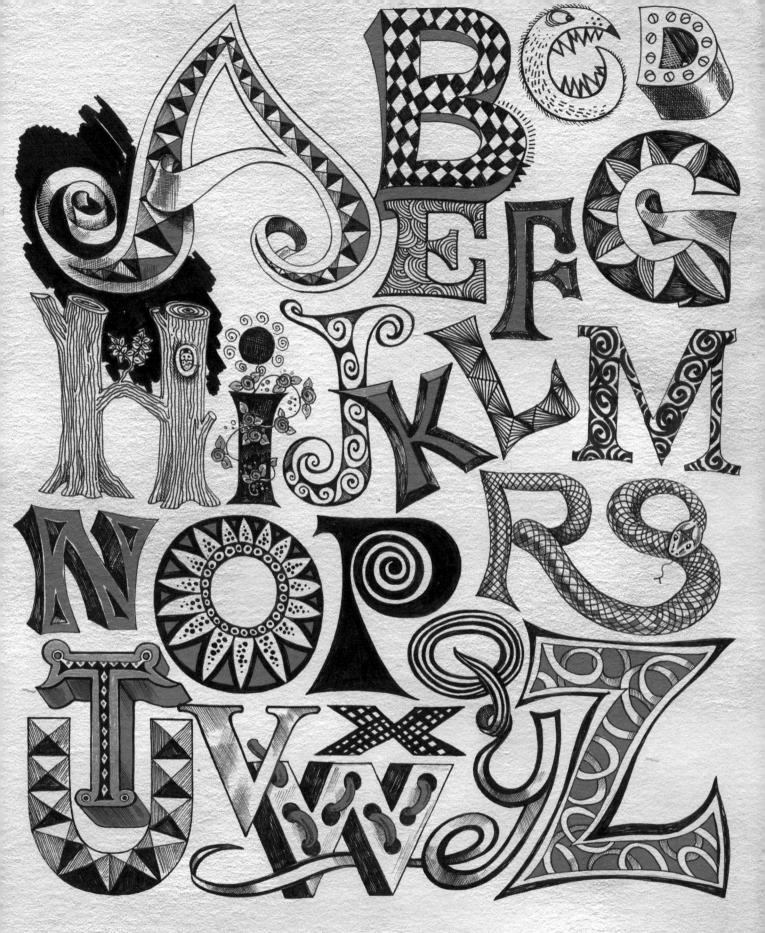

This alphabet has been assembled by combining a lot
of different sketchbook ideas for lettering.

49

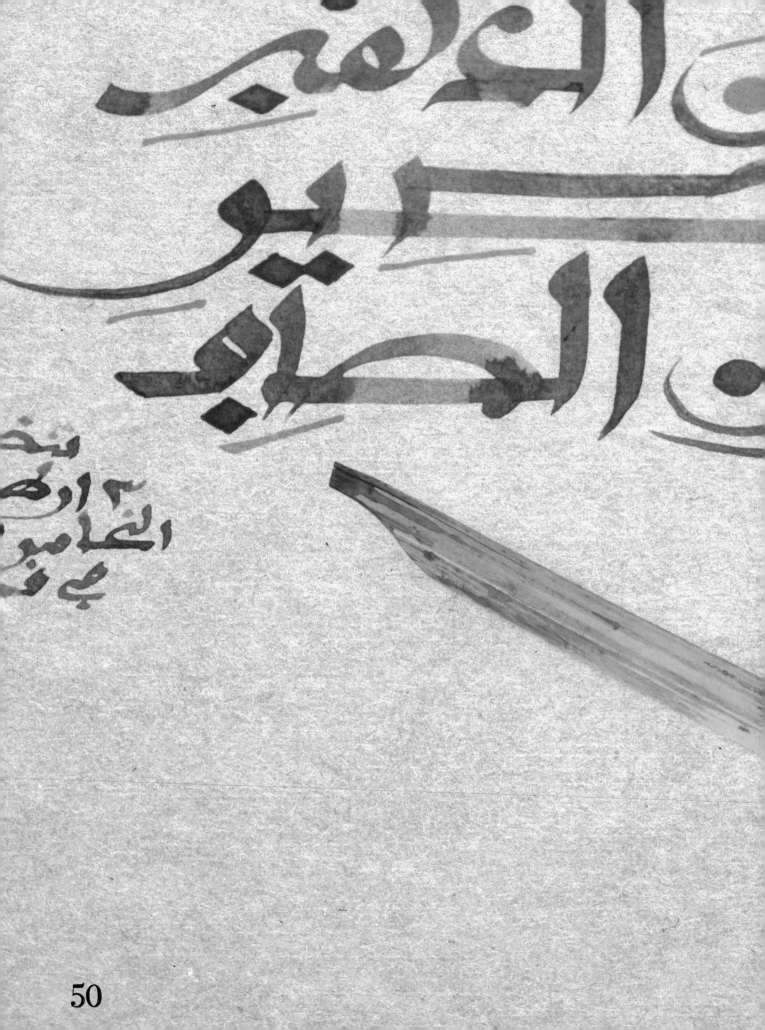

50

# CHAPTER IV
# PEN AND INK

## Materials

- Brush
- India ink
- Paper
- Pencil

## Technique

1. Lightly pencil in the letter shape. (fig. A.)

2. Begin at the top line. Apply the ink in one movement: left to right and lift to create a tapering brushstroke. (fig. B.)

3. Start the diagonal from the bottom of the letter and take the brush up, thick to thin. (fig. C.)

4. Start the baseline from the left and take the brushstroke across—thick to thin. (fig. D.)

With practice you will develop your own personal style. Try to be consistent with stroke thickness.

# Loose brushstrokes

Brush letterforms were most popular in the 19th century when sign-painting was needed for advertising. Lowercase and uppercase letters are quickly formed with a few brushstrokes. Brush letterforms tend to look highly individual. It is best to quickly sketch out some ideas before you begin.

fig. A.

fig. B.

fig. C.

fig. D.

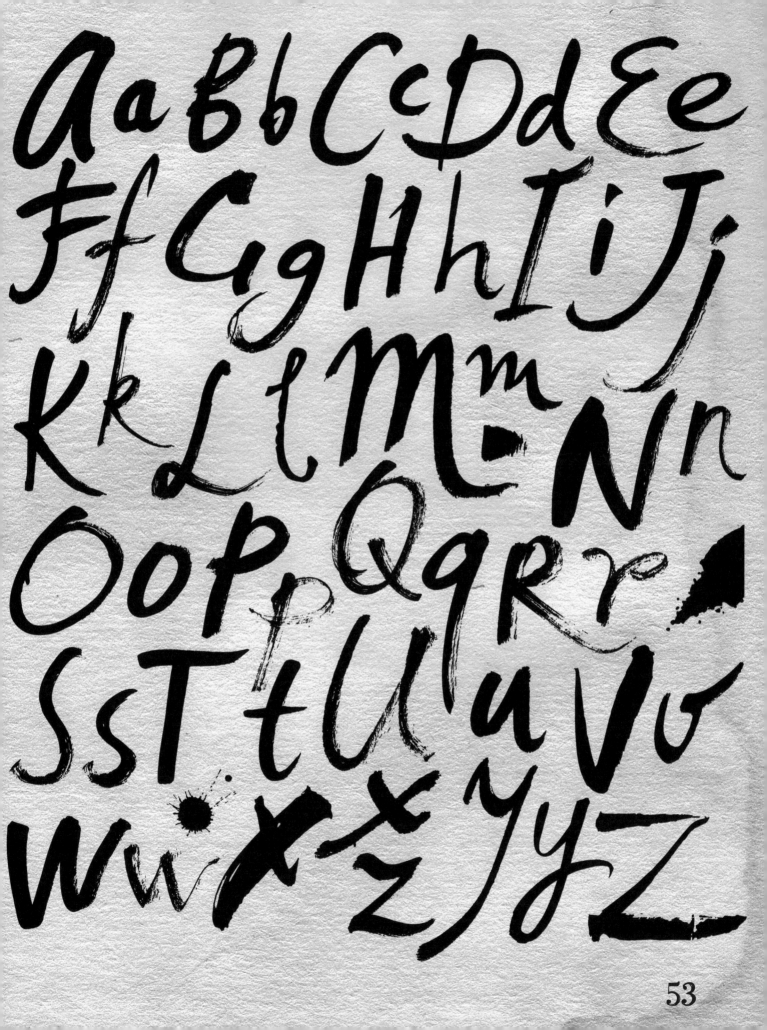

Aa Bb Cc Dd Ee
Ff Gg Hh Ii Jj
Kk Ll Mm Nn
Oo Pp Qq Rr
Ss Tt Uu Vv
Ww Xx Yy Zz

## Materials

- Brush-pens
- Watercolor paper (HP)

Not all brush-pens are the same as pen pressure varies from one to another. The tip or nib is made from natural or synthetic materials that can affect the sensitivity of the brush tip. Soft tip pens require light pressure, but hard tip pens need more pressure for the thicker strokes. Experiment with a variety of pens. Practice writing letters that have repetitive up and down movement.

## Technique

1. Sweep the pen downward and lift to create an oblique angled stroke. (fig. A.)

2. Starting at the top, move the pen in a downward curve. (fig. B.)

3. Complete the letter with a final downward stroke. (fig. C.)

4. Practice different strokes. (fig. D.)

# Brush-pen alphabet

**B**rush-pens are an alternative to paintbrushes. The fluid line of a brush-pen creates the same effect and construction as a regular brush. Brush-pens are easy to use and help speed up the process of creating a brush-script letterform.

fig. A.

fig. B.

fig. C.

fig. D.

The brush-pen's downward strokes look thicker where more pressure has been applied. The upward or sideways strokes create a slightly thinner line.

54

ABCDE
FGHIJK
LMNOP
ORSTU
VWXYZ

ÅÅÄÅ
ÆÇÉ
É
Çéé
éëíí
iðñõ
óôõö

abcde
fghil
lmno
grst
vwxy

ÒÓ
ÖÕ×

øÚÛ
áâãã
äåœ

@%
)&×
(-+·

55

# Arabic

Arabic is written in many beautiful scripts. Some are used mainly for religious writings or private letters. Islamic scribe (below) with writing instruments.

Realistic pictures are forbidden in Islamic art. So mosques—Muslim holy buildings—are decorated with abstract patterns and include sayings from the Koran. Muslims believe that writing is a gift from Allah. Buildings, clothes, and ceramics are beautifully decorated with holy words.

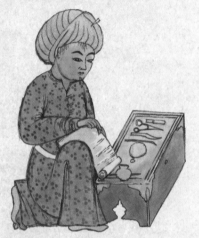

Arabic is a language spoken by more than 420 million people. It is the sixth most spoken language. It is also an alphabet used to write other languages like Persian, spoken in Iran and Afganistan, and Urdu, spoken in India and Pakistan. The Arabic alphabet was invented 1,300 years ago, to write down the words of Allah, as revealed to the prophet Muhammad. Ever since, Muslims across the world have read the Koran, the Islamic holy book, in Arabic. Arabic numerals are used globally.

*Kaifa haluka* is Arabic for *How are you?* It is shown here in four different Arabic writing styles.

These letters are written separately. When joined, the letter shapes change depending on where they are positioned in a word. Arabic, like Chinese, is read from right to left.

Iranian Farsi nastaliq

Kufic fatimiyyah

كيف حالك

Iranian moalla

كيف حالك

Ruq'ah

كيف حالك

# Arabic alphabet cloud

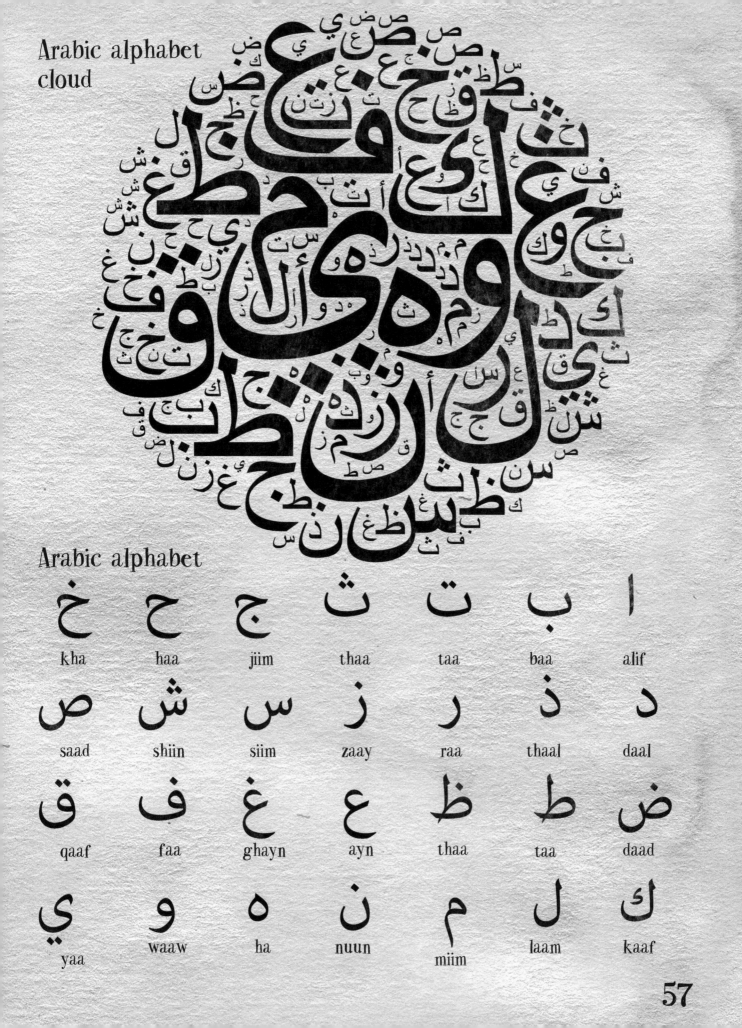

## Arabic alphabet

| | | | | | | |
|---|---|---|---|---|---|---|
| خ | ح | ج | ث | ت | ب | ا |
| kha | haa | jiim | thaa | taa | baa | alif |
| ص | ش | س | ز | ر | ذ | د |
| saad | shiin | siim | zaay | raa | thaal | daal |
| ق | ف | غ | ع | ظ | ط | ض |
| qaaf | faa | ghayn | ayn | thaa | taa | daad |
| ي | و | ه | ن | م | ل | ك |
| yaa | waaw | ha | nuun | miim | laam | kaaf |

### Materials

- Bamboo reeds or bulrush
- Ink
- Craft knife
- Paper

### Technique

Reed pens are made by cutting and shaping a single length of bamboo or bulrush reed.

## fig. A.

1. Dip a reed pen in ink so that the center fills with ink. As you draw, the ink slowly seeps down to the carved nib. (fig. A.)

2. Practice holding the pen comfortably, and try different sized strokes. (fig. B.)

3. The reed pen needs to be dipped as you draw. Gradually, the pen's point will wear down and thicken. Sharpen it with a craft knife.

# Diwani script

Diwani, a variety of Arabic script, was designed by Housam Roumi. It was most popular under Süleyman I the Magnificent (1520–1566). The original word "Dewan" is derived from Persian and means "bundle" (of papers) or "book." The word changed to "Diwan" or "di-van," named after the long, cushioned seats in the council chambers of the sultan's palace. This highly decorative script was used by palace calligraphers for the writing of all royal decrees.

## fig. B.

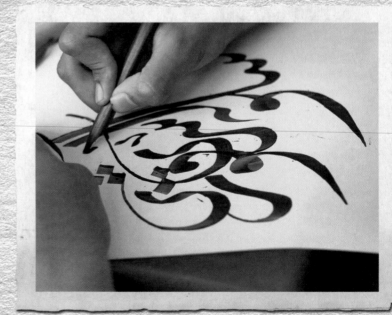

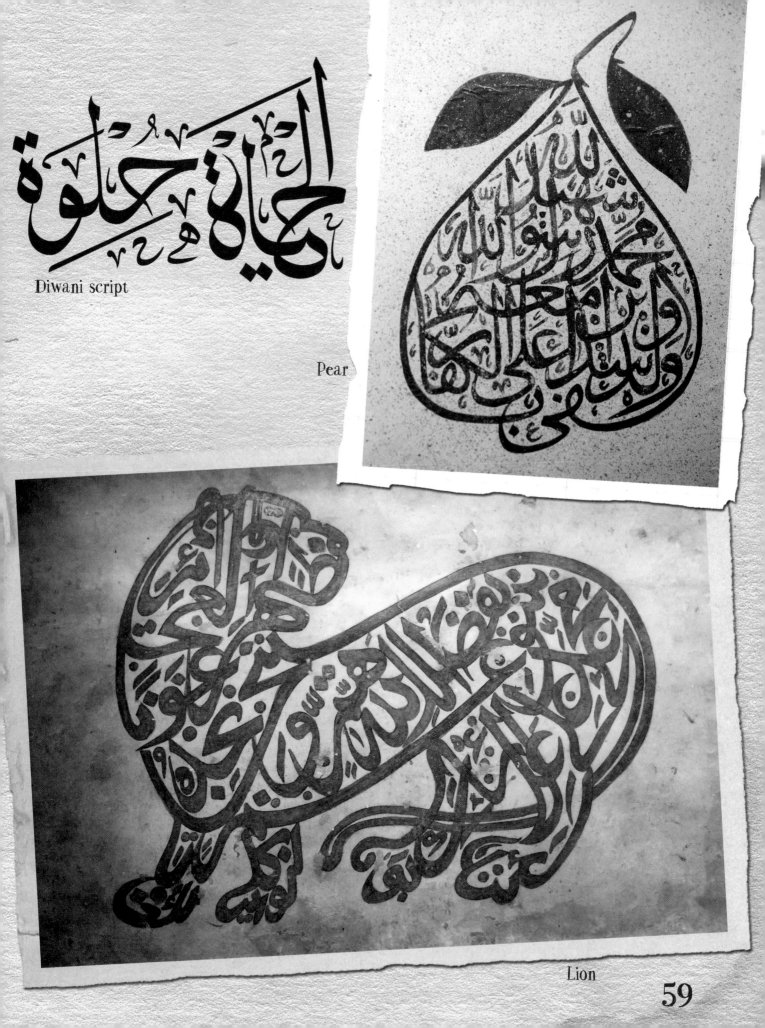

الحياة حلوة

Diwani script

Pear

Lion

59

## Writing with brushes

### Materials

- Inkstick
- Paper (50 ft or 15.24 m rolls are available to practice)
- Inkstone for grinding
- A paper weight, to anchor the paper
- Cloth (or newsprint) to place under the paper to prevent the ink bleeding
- "Combination brushes": soft outer hairs "strengthened" by a hard bristle core

ありがとう

Thank you

おせ話になります

Best regards

# Japanese

Traditionally, Japanese was written in vertical columns called *tategaki*. Each column was read from top to bottom and progressed from right to left. *Yokogaki*, a horizontal writing format that reads from left to right, is commonly in use now and is popular with younger generations.

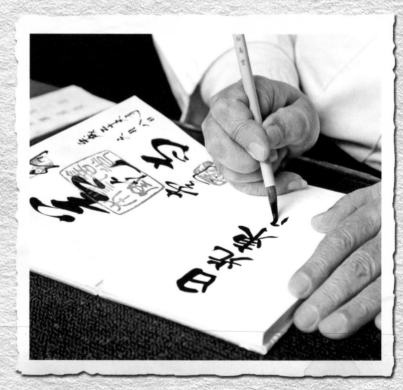

An inkstick is made from pine wood, soot, and glue. Traditionally, ink is made by grinding an inkstick in water against a stone or slate using a circular motion. The Japanese perfected the bottled ink *bokuju*, which makes ink convenient and easy to use.

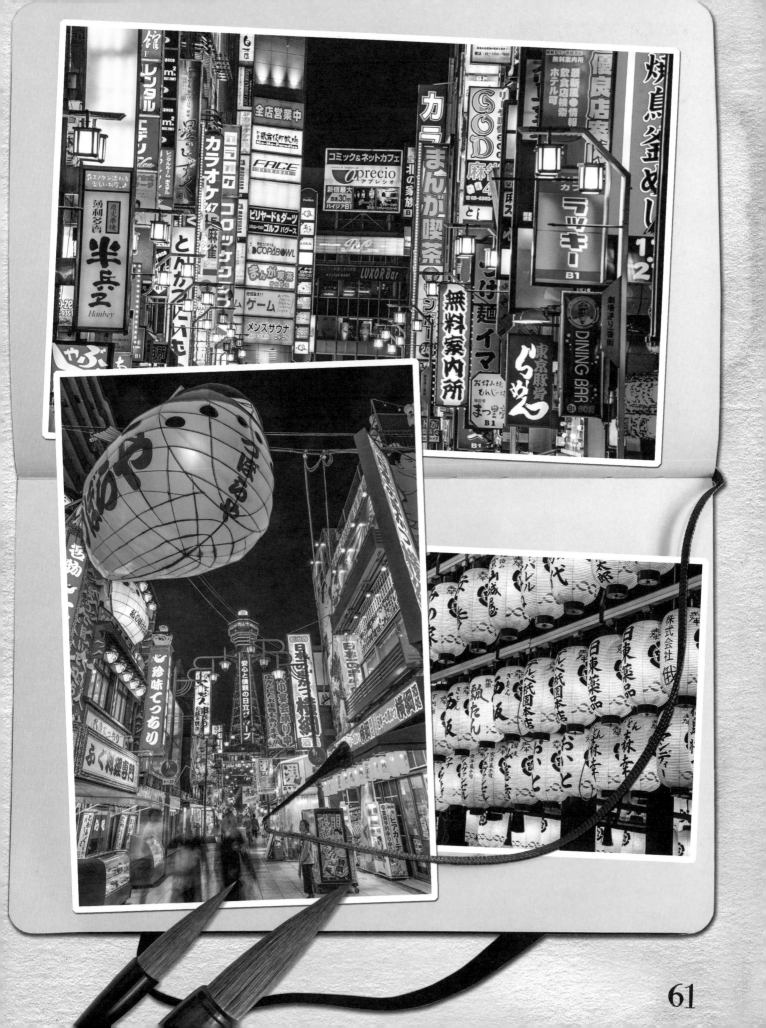

## Writing with pictures

### Calligraphy

About 1,500 years ago, Japan and Korea used Chinese characters for writing. Japanese still uses many Chinese characters. But in Korea they were replaced by an alphabet created by King Sejong in 1443.

Calligraphy is the art of beautiful writing. Chinese calligraphers spend years perfecting their style. Legend says that Chinese writing was invented by Cang Jie. He copied the tracks of animals and birds.

The earliest known printed book is a Chinese translation of a Buddhist text, called Diamond Sutra. It was printed with carved wooden blocks in 868 BCE.

Chinese characters can be made up of more than 20 brushstrokes.

# Picture writing

The Chinese writing system is still in everyday use. It has hardly changed since it was developed 4,000 years ago, so modern Chinese people can read ancient texts. Chinese is based on picture writing. Common words, like "home" or "fire," are picture signs. Other words are built up from sounds. There are over 50,000 characters (signs), and you would need to know about 2,000 to read the newspaper.

Chinese characters are written with animal-hair brushes.

一 二 三 四 五 六 七 八 九 十 百 千 東 南 西 北

神 魔 歡 象 負 飛 筷 網

你 我 高 低 死 活 吃 喝 愛 恨

快 慢 上 下 輸 贏 惡 孩 齒 天 痛 煩 口 鼠 牲 耳

法 牛 山 廟 燈 紙 睡 犬 煙 聲 餐 田 巾 方 圓 腔 臉

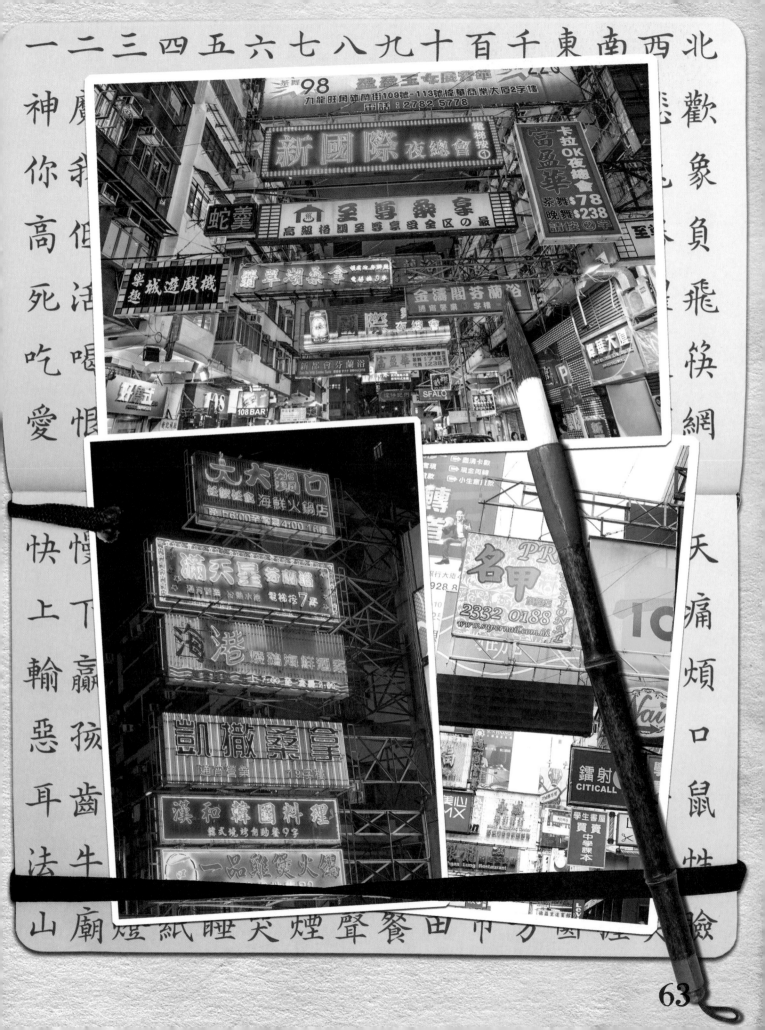

## Materials

- Brushes
- Pens
- Paper
- Black ink
- Colored inks or watercolors

## Pens

Pens and the type of nib used make a vast range of thick or thin marks depending on pressure applied and the fluidity of the pen.

## Making marks

The kind of pen preferred will depend on the type of line you want to draw. Try out a range of nib sizes to find out what is best for the type of work you wish to do. Try and keep an open mind as accidental marks can be exciting.

## Negative space

When using ink on paper, two colors are being used: the color of the ink and the color of the paper. Blank or "negative" space is important. Try out different colors of paper and ink to give variety to work.

# Pen and brush

The elegant style of the Islamic, Chinese, and Japanese scripts seen on previous pages have taken calligraphers many years to master. The fluid line of a pen or brushstroke can vary in width depending on the amount of pressure applied to the up or down stroke. Practice lots of different styles with one letter. Try working in colored inks too for greater variety.

## Materials

- Brushes
- Watercolors
- Watercolor paper (HP)
- Pencil
- Eraser

## Technique

1. Lightly pencil in block shaped letters. (fig. A.)

2. Try different techniques: **Wet-on-wet**, applying wet paint onto wet paper creates unexpected and exciting results. **Wet-on-dry**, apply a wash of color. Once dry, paint on top of it.

3. Charge the brush with paint, and very loosely apply it inside the pencil lines. When the paint is dry, use an eraser to remove the lines. (fig. B.)

# Watercolor

**W**atercolors are an ideal medium for experimenting. All you need is a box of paints, a pencil, a brush, paper, and water.

*fig. A.*

*fig. B.*

ABCDEFG
HIJKLMN
OPQRSTU
VWXYZ

ABCDEF
GHIJKLM
NOPQRS
TUVWXYZ

67

# Writing

## Materials

- Dip pen
- Nibs
- Ink
- Pencil
- Eraser

## Technique

1. Draw lines that are an equal distance apart. (fig. A.)

2. Practice writing the alphabet. Follow the red arrows indicating the direction that the pen moves to form each letter. (fig. B.)

When handwriting, note the shape, angle, and spacing between letters as you progress. Try to maintain a consistent pressure on the pen nib.

Cursive script means joined-up writing, otherwise known as longhand. Cursive script flows better and was devised to speed up the writing process. Handwriting develops in many individual styles. Often a person's writing can be instantly recognizable because of their particular way of shaping or spacing letters.

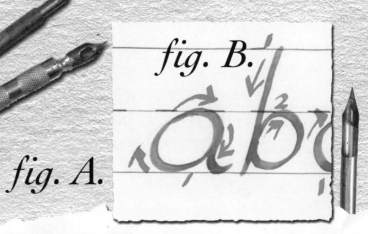

*fig. B.*

*fig. A.*

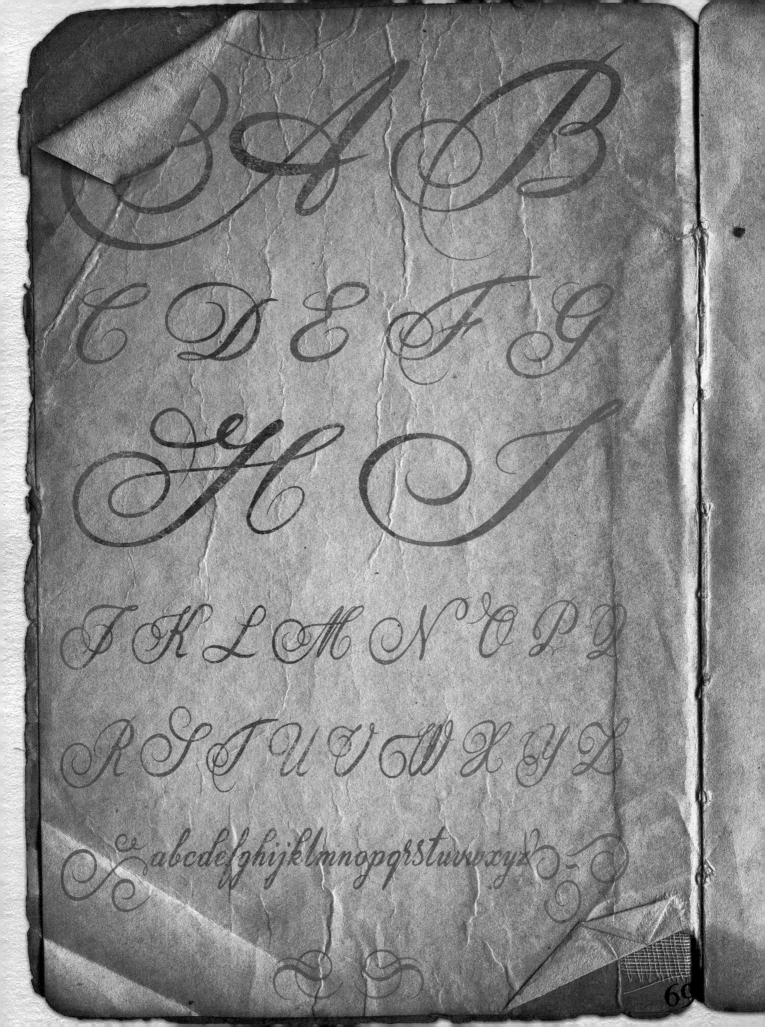

A B

C D E F G

H J

I K L M N O P Q

R S T U V W X Y Z

abcdefghijklmnopqrstuvwxyz

## Materials

- Felt-tip pen or fiber-tip
- Watercolor paper (HP)
- Graph paper
- Pencil

Sketch your design on scrap paper or graph paper. Draw a squared grid of black lines to use under the paper to create letters of the same scale.

## Technique

1. Construct the letter shape in squares and lightly pencil in crosses. (fig. A.)

2. Add more definition to the letter. (fig. B.)

3. Using a felt-tip pen, draw in one set of diagonals. (fig. C.)

4. Complete the crosses with felt-tip pen. Remove the pencil lines with an eraser. (fig. D.)

This example was drawn "freehand." If a more regular shape is required, a ruler should be used.

# Line stitching

A cross-stitch alphabet, inspired by a traditional form of embroidery, builds up patterns in X-shaped stitches. The uniform stitch style is applied to an evenweave fabric. Graph paper could easily be used to design letters to the same effect.

## fig. A.    fig. B.

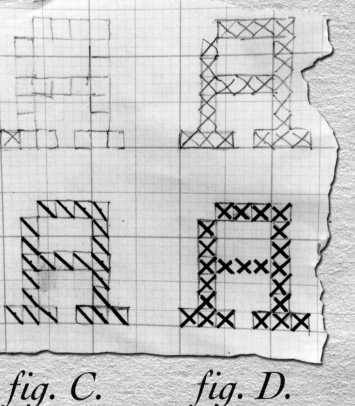

## fig. C.    fig. D.

Cross-stitch is one of the oldest forms of embroidery. Traditionally, an alphabet "sampler" was sewn by a young girl learning how to sew.

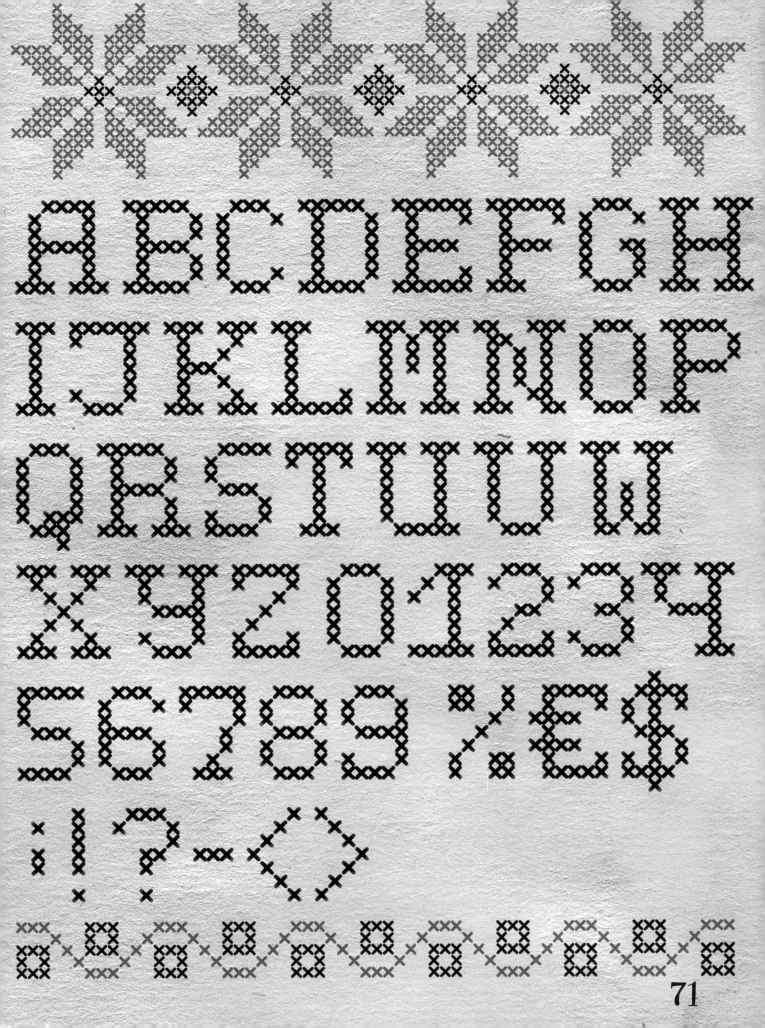

ABCDEFGH
IJKLMNOP
QRSTUVW
XYZ01234
56789%£$
:!?-<>

71

# Patterned capitals

**D**ecorated with random patterns, these capital letters can be used at the start of names, words, or sentences in the medieval manuscript tradition. The patterns can be contained within the letter shape or flow freely, but the letter should always be legible.

*fig. A.*

*fig. B.*

*fig. C.*

*fig. D.*

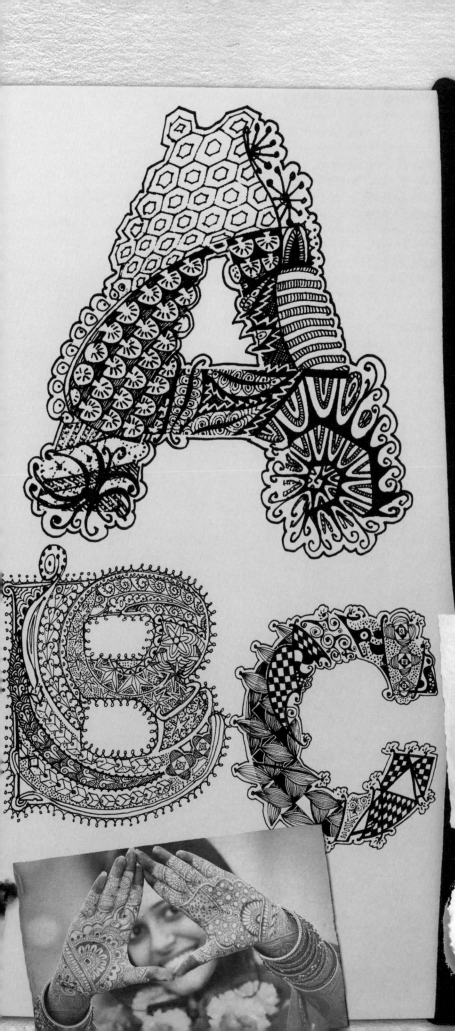

## Materials

- Paper
- Pencil
- Felt-tip pen
- Eraser

## Technique

1. Sketch in a block-shaped letter A. (fig. A.)

2. Lightly sketch in baroque style patterns that spill over the outline of the letter. (fig. B.)

3. Use a felt-tip pen to ink in the penciled patterns. (fig. C.)

4. Add more detail to the patterns. Once complete, remove unwanted pencil lines with an eraser. (fig. D.)

## Mehndi

Traditionally, in India and Pakistan, henna artists draw mehndi patterns of a similar nature on the hands and feet of bridal parties in lavish pre-wedding celebrations.

## Technique

1. Sketch in a block-shaped letter M. (fig. A.)

2. Lightly sketch in patterns that spill over the letter outline. (fig. B.)

3. Use a felt-tip pen to ink in the penciled patterns. (fig. C.)

4. Add more detail to the patterns. Once complete, remove unwanted pencil lines with an eraser. (fig. D.)

# Patterned alphabet

The letters in this alphabet are heavily patterned. Use a small notebook to add letters and patterns gradually to build up a complete alphabet over time. Seemingly complex patterns can be built up from simple shapes.

*fig. A.*

*fig. B.*

*fig. C.*

*fig. D.*

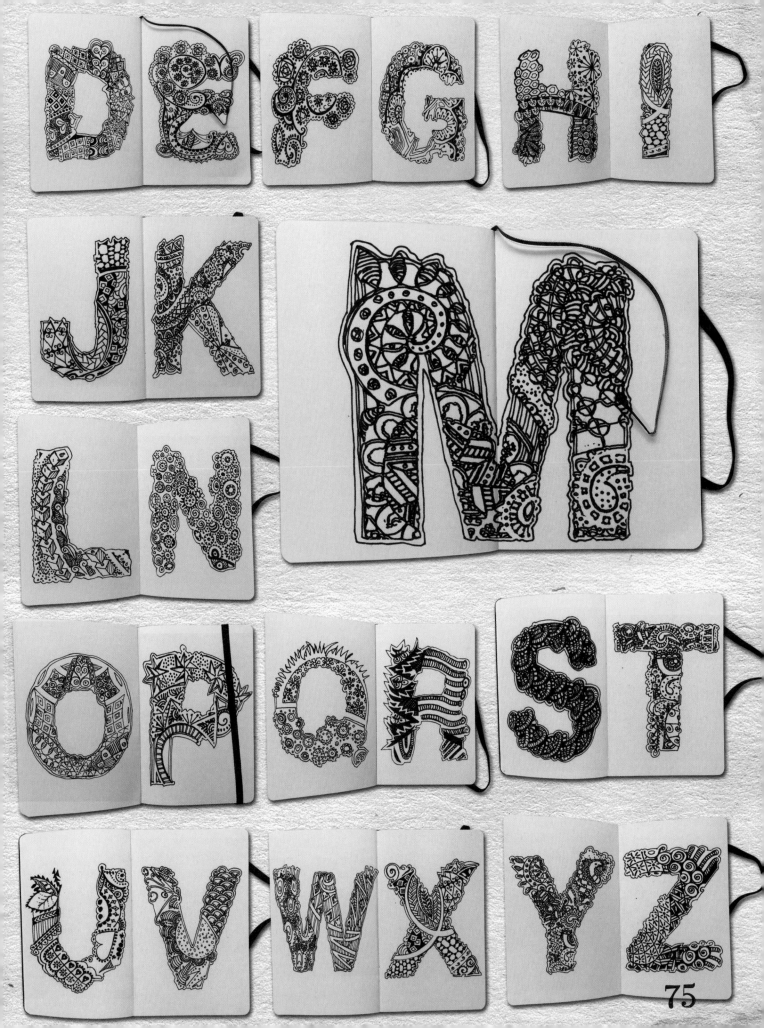

# Letter picture

## Materials

- Pencil
- Paper
- Felt-tip pen
- Eraser

Pencils, colored pencils, or felt-tip pens can be used. Practice on scrap paper or layout paper. Learn how to use a variety of materials, and don't be afraid to experiment with different kinds of marks.

**L**ettering can be used to make pictures as well as words. The scale, direction, and shape of the letters can be totally random. Place them in any position—vertical, diagonal, horizontal, or even upside down. These letters are not meant to be read.

*fig. A.*

*fig. B.*

## Technique

1. Sketch out or trace a horse and rider. (fig. A.)

2. Start drawing in letters and slowly build up your image. (fig. B.)

3. Use a felt-tip pen over the pencil lines. Once dry, remove any unwanted pencil lines with an eraser. Continue to work over the artwork until complete. (figs. C and D.)

*fig. C.*

*fig. D.*

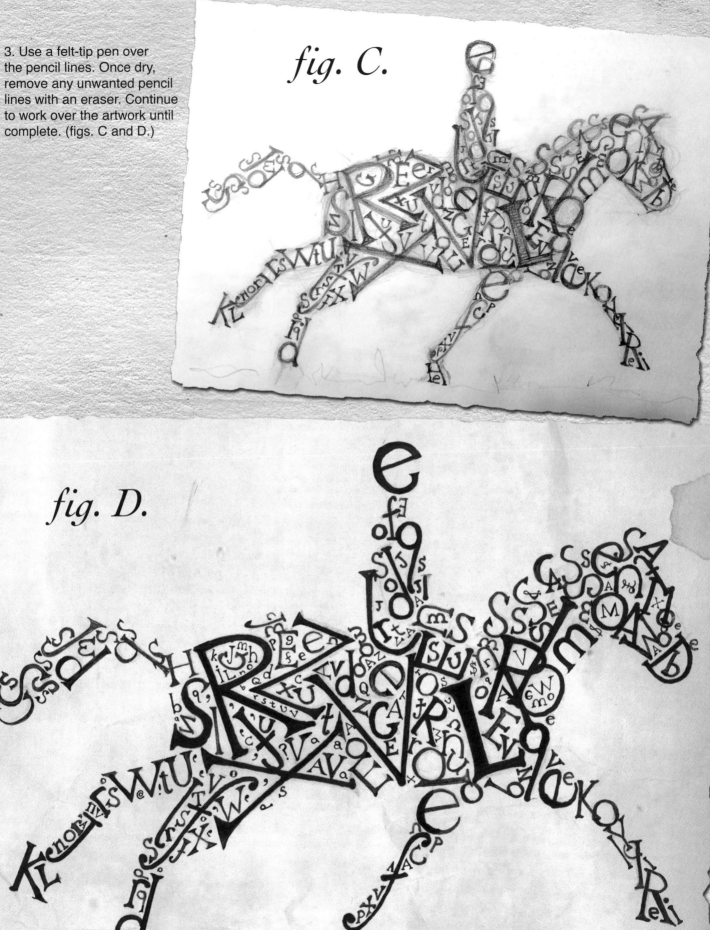

# Picture letters

## Materials

- Card
- Magazine images
- Glue
- Scissors

## Technique

1. Choose images to cut out of magazines—try to keep to a theme. (fig. A.)

2. Glue them onto a sheet of card to photocopy or scan to print in a range of sizes. (fig. B.)

3. Draw a letter shape in pencil. (fig. C.)

4. Cut out the photocopied images. (fig. D.)

5. Arrange the shapes before gluing in place. Start with the largest ones first. (fig. E.)

6. Fit the smaller shapes around and in between the larger ones. Remove unwanted pencil marks when glue is dry. (fig. F.)

**A**dding a theme-based collage within the shape of a letter can create an interesting result, too. Collage allows for experimentation with a wide range of colors and textures. A large letter could be made up of all different styles and colors of the same letter cut from magazines and newspapers.

*fig. A.*   *fig. B.*   *fig. C.*

*fig. D.*   *fig. E.*   *fig. F.*

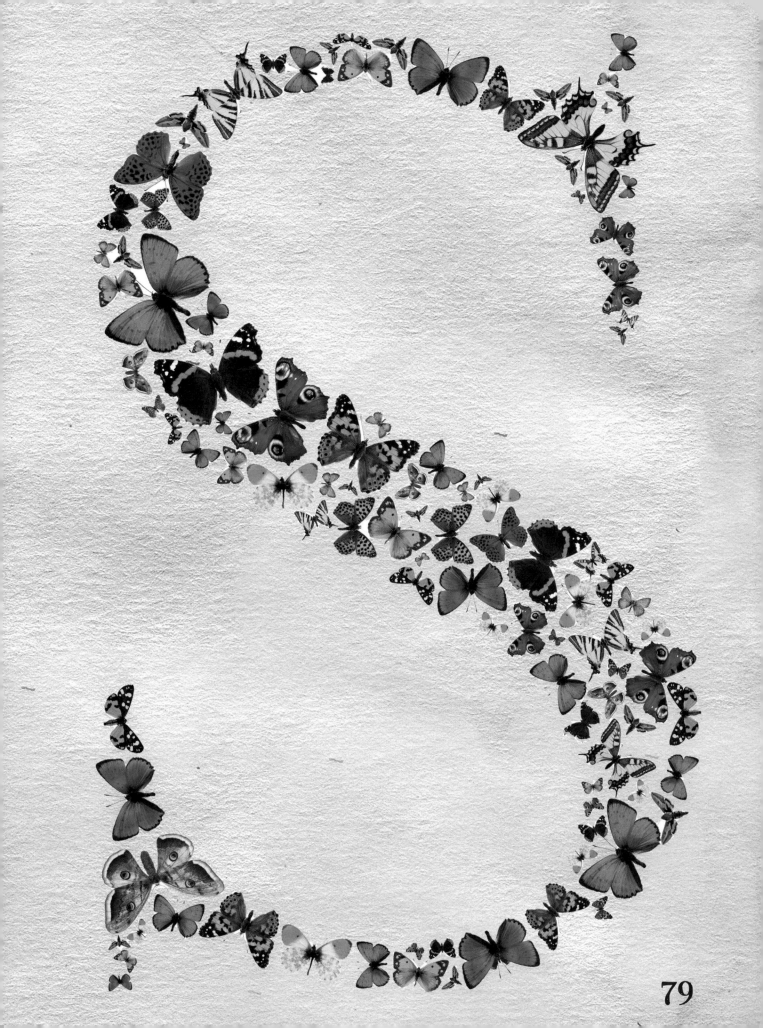

# CHAPTER V
# HANDMADE

# Collage letters

## Materials

- Patterned paper
- Felt-tip pen
- Scissors or craft knife
- Glue
- Tracing paper

## Technique

1. Draw a bold block style alphabet on tracing paper. A simple letter style is easier to cut out with scissors or a craft knife. (fig. A.)

2. Flip the tracing paper and draw the letters in reverse onto the back of the patterned paper. (fig. B.)

3. Cut out the letter shapes with a craft knife or scissors and glue to a background. Use a felt-tip line to add definition or weight to each letter as required. (fig. C.)

A collage can be made of printed paper or found objects from many different sources. Collage is an enjoyable and satisfying way to create an alphabet. Printed wrapping paper has been used to make this alphabet, but photographs and magazines can be used to great effect.

*fig. A.*

*fig. B.*

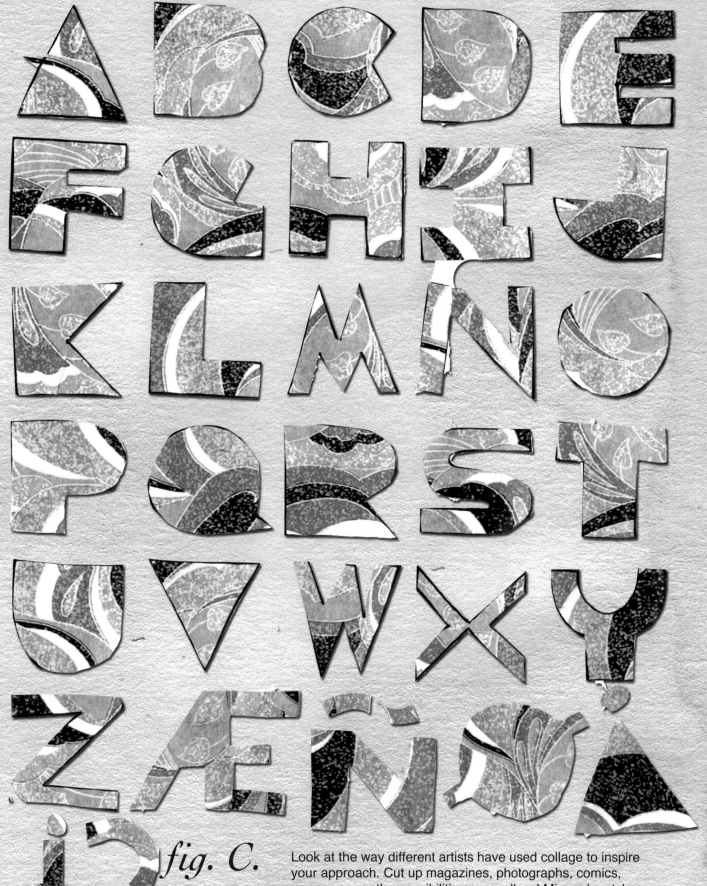

*fig. C.*

Look at the way different artists have used collage to inspire your approach. Cut up magazines, photographs, comics, newspapers—the possibilities are endless! Mix and match letters cut out of plastic bags, canvas, or scraps of cloth. If you can cut it, use it!

## Materials

- Glue
- Old books, magazine
- Scissors
- Paper or card

## Technique

1. Select and cut out your choice of images. (fig. A.)

2. Arrange the shapes into letter forms. (figs. B and C.)

3. Glue each section into place. (fig. D.)

# Collage

Using letters constructed from found printed material can make a fantastic collage. These skeleton letters were assembled from an old anatomy book. An alphabet like this can also be assembled by doing an "eCollage"— an electronic version created using computer tools.

*fig. A.*

*fig. B.*

*fig. C.*

*fig. D.*

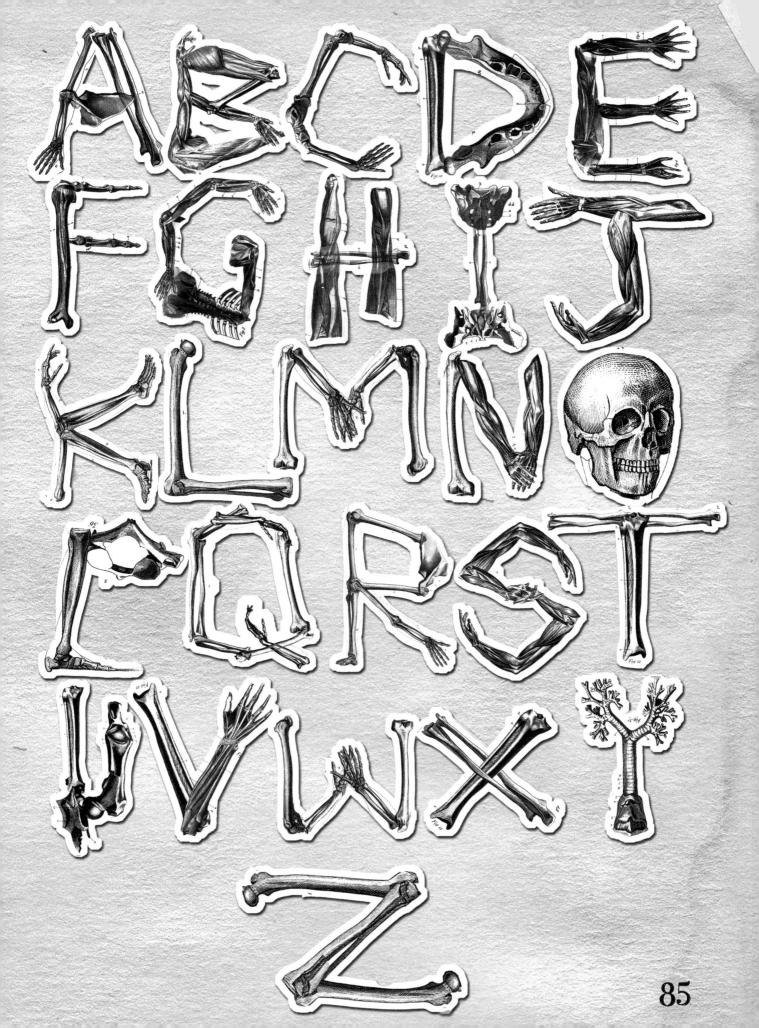

## Materials

- Pencil
- Paper

## Technique

1. Pencil in a double spiral on paper.

2. Start sketching in the alphabet so you have an idea of how much space it will take up.

3. Block in the letter shapes.

4. Refine the letter shapes so that you know exactly what style of letter you want to use. Be consistent.

Before you begin, it is a good idea to have a "reference sheet" for the style of letter that you plan to draw so you can refer to it.

# Letter spiral

Painted lettering on china turns it into a highly personal object that can be used as a gift. It needs to be planned out carefully.

86

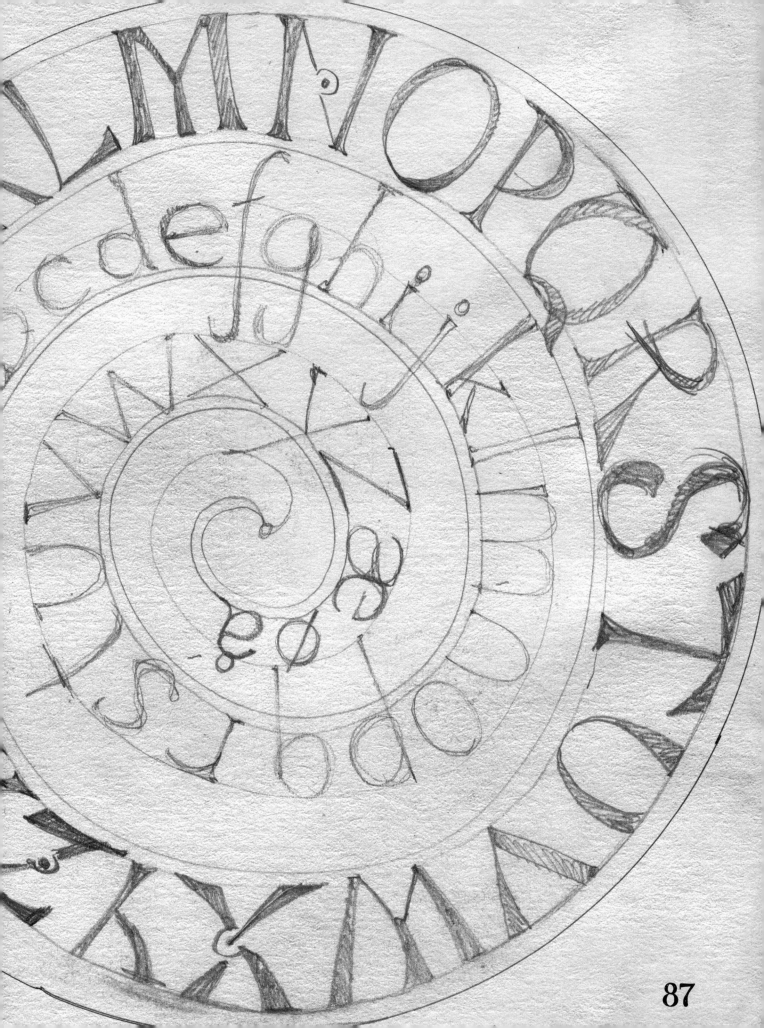

## Materials

- Water-based porcelain paint pens in a variety of nib sizes and colors
- Pencil
- Alcohol wipes for degreasing

## Technique

Always clean the piece of china with an alcohol wipe to degrease the surface before painting.

1. Lightly pencil in a double spiral. (fig. A.)

2. Pencil in the outline of each letter. Drawing in freehand creates a very personal style. (fig. B.)

3. Use the porcelain paint pens to block in color. A limited color palette can create a more cohesive look. (fig. C.)

4. Once the paint is completely dry, the plate is baked in the oven for about 35 minutes. Please follow the pen manufacturer's instructions regarding timing and temperature. Once cooked, the process is complete. (fig.D.)

# Painted plate

Water-based porcelain paint pens are easy to apply and come in a wide range of paint colors and nib sizes. The painted china can be baked in an oven to make the design permanent.

*fig. A.*

It is not a problem if you make an error or do not like the way your design is working out. The paint is water-based so it can be washed off at any stage prior to heating.

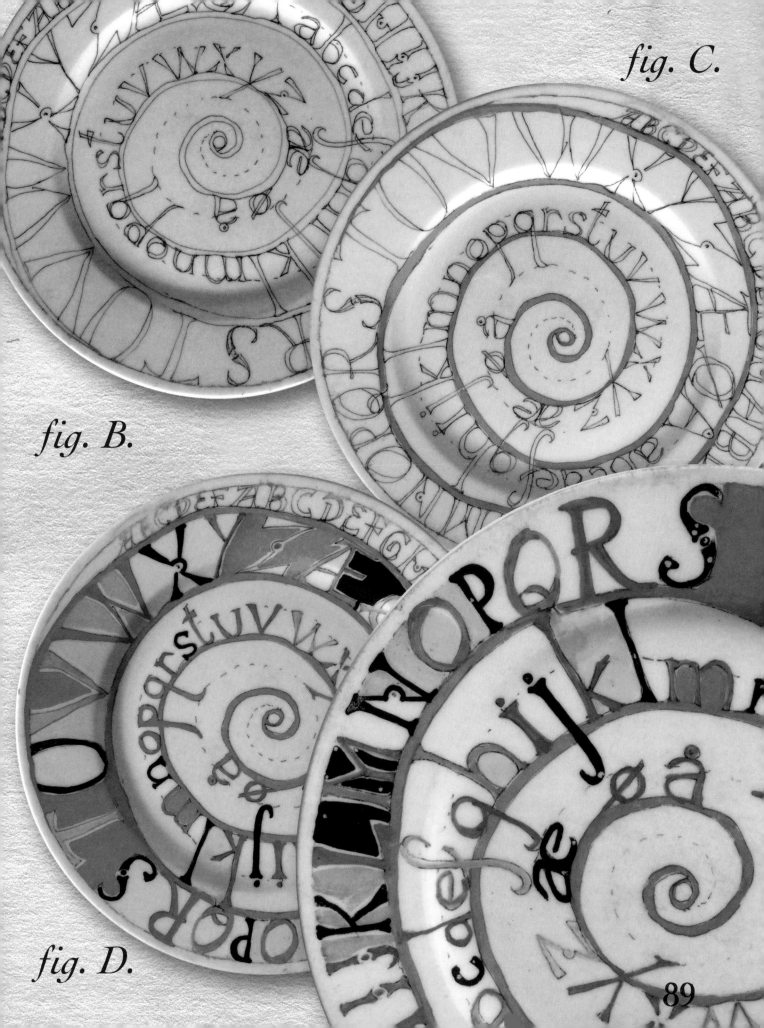

*fig. C.*

*fig. B.*

*fig. D.*

89

## Materials

- Letter templates
- Pencil
- Felt-tip pens
- Watercolors
- Inks
- Scissors
- Paintbrush

Pencils, felt-tip pens, wax crayons, and colored pencils can be used on scrap paper or layout paper before starting on a finished alphabet.

## 3D Letter Technique

1. Hold the template firmly while drawing the shape of the letter in pencil. (fig. A.)

2. The pencil outline. (fig. B.)

3. Draw horizontal lines that appear to rise up and over the letter shape. (fig. C.)

4. This method creates an optical illusion that the letter is raised up. (fig. D.)

# Stencil lettering

Stencils made of plastic, card, or brass can be used as a template to maintain consistency of style and size of lettering. The template drawing can then be used as a starting point for creating many different styles.

*fig. A.*

*fig. B.*

*fig. C.*

*fig. D.*

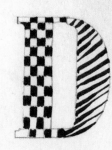

A. Pencil scribbled-over template

B. Brush-shaped felt-tip pen over template in varying dot size

C. Brush-shaped felt-tip pen on pencil

D. Brush-shaped felt-tip pen on pencil

E. Brush-shaped felt-tip pen, short strokes

I. Texture from a magazine

J. Brown felt-tip on top of orange felt-tip

F. Ink pen, short strokes and cross-hatching

G. Pencil outline, felt-tip pen varying strokes

H. Felt-tip pen

N. Brass stencil

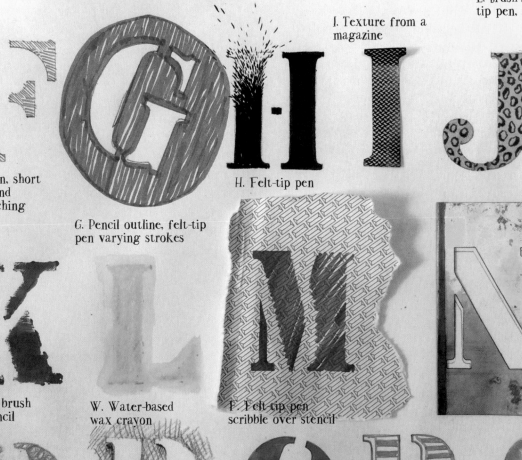
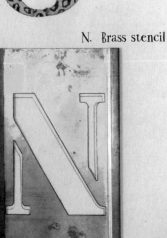

K. Paint brush over stencil

W. Water-based wax crayon

P. Felt-tip pen scribble over stencil

O. Colored pencil scribble

P. Pencil cross-hatch

Q. Ink

R. Felt-tip

S. Ink on water

T. Red felt-tip squares on yellow felt-tip

U. Felt-tip

V. Watercolor

W. Pencil outline, ink

X. Pencil outline, ink

Y. Felt-tip scribbles

# Paper folding

**S**trips of paper have been folded to create these origami-inspired letters. These examples have been made from cut paper, torn paper, patterned paper, and paper that has had ink patterns doodled on to it.

## Materials

- Paper
- Scissors
- Glue

## Origami

Origami is the art of folding. Any flat material can be used as long as it can hold a crease. Traditional Japanese origami has been practiced since the Edo period (1603–1867).

## Kirigami

The Japanese word *kirigami* refers to paper that has been folded and cut. Cutting is more characteristic of Chinese papercrafts.

## Technique

1. Draw a squared grid on a sheet of paper. (fig. A.)

2. Roughly shade in the letter shape on the squares. (fig. B.)

3. Cut a piece of paper the width of the square and cut into strips. (Use paper that is patterned on one side.) Make folds to form the shape of the letter (as shown) following the shaded areas. (fig. C.)

*fig. A.*

*fig. B.*

*fig. C.*

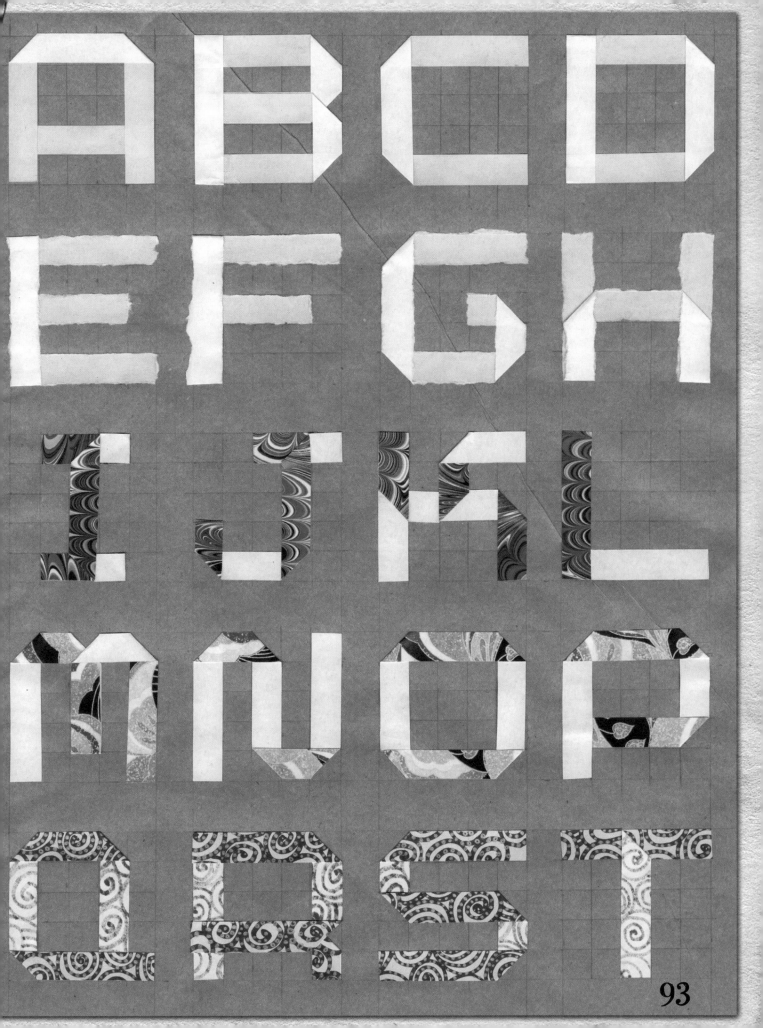

93

# Folded paper

O rigami-inspired letters made from strips of paper are a simple way to make three-dimensional letters that can be glued onto a backing sheet. The letters can be drawn on to enhance or exaggerate the folds. Paper colored or patterned on one side is effective for this project.

## Materials

- Water soluble wax pastels
- Watercolor paper (HP)

Pencils, colored pencils, or felt-tip pens can be used. Practice on scrap paper or layout paper. Draw a black square to use under the paper as a guide so that the letters are drawn to a similar scale.

## Technique

1. Start by drawing a pencil grid, five squares wide by six squares high. (fig. A.)

2. Use pencil shading to indicate the shape of the letter. (fig. B.)

3. Glue strips of paper to form the letter. Fold as shown. Note: In this example, the paper used is colored on one side only. Outline the white-edged paper with black fineliner. (fig. C.)

4. To make the letter appear 3D, add ballpoint pen and white gel pen cross-hatching. Choose a light source; then add pencil shading to create shadows where light would not reach. (fig. D.)

*fig. A.*    *fig. B.*

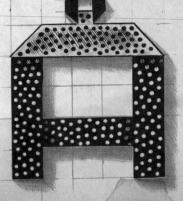

*fig. C.*    *fig. D.*

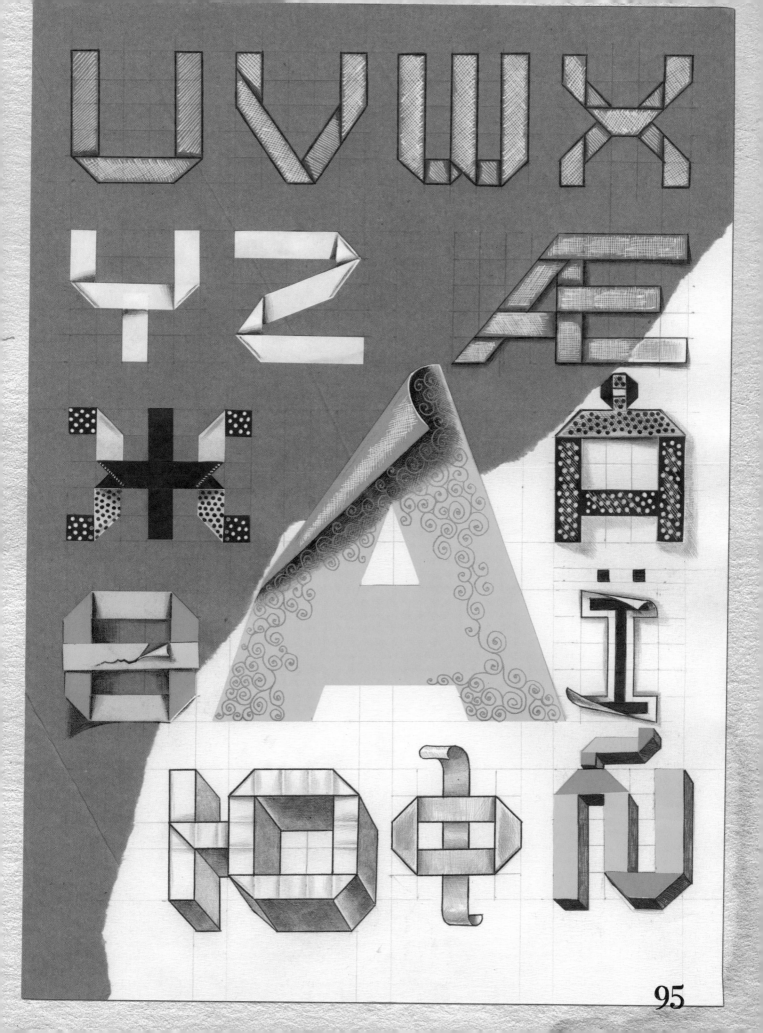

# Graph paper

## Materials

- Graph paper
- Pencil
- Pen
- Eraser

The gridded format of graph paper makes it easy to produce letters that are the same dimensions. You can make your own graph paper by drawing guide-lines on paper using a pencil and ruler.

## Technique

1. Sketch ideas for the shape of the letter. (fig. A.)

2. Block in the shape of the letter. (fig. B.)

The grid patterns on graph paper are useful for designing modern letter shapes. Draw directly onto the graph paper or use it underneath your paper as a guide for spacing and letter height.

*fig. C.*

*fig. A.*

*fig. B.*

3. Remove unwanted pencil lines with an eraser. (fig. C.)

4. Block in the shape of the letter with a pen. (fig. D.)

*fig. D*

Hand-lettering often begins with a pencil sketch, which is inked over. Keep your pencils sharpened to produce nice clean lines.

## 3D alphabet

- Felt-tip pens and pencils
- Paper

Pencils, colored pencils, or felt-tip pens can be used. Practice on scrap paper or layout paper. Draw a square in black ink to use under your paper as a guide to drawing the letters to a similar scale.

## Technique

1. Pencil in each letter in capital and lowercase format. (fig. A.)

2. Outline the letter as shown. (fig. B.)

3. Draw in short angled lines in the direction and angle of the shadow required. (fig. C.)

4. Add remaining lines to complete the 3D effect. (fig. D.)

5. Ink in the outline. Remove unwanted pencil lines with an eraser. (fig. E.)

6. Use directional hatched lines to block in the shadows. (fig. F.)

# Drawing shadows

**D**rawing shadows on letters makes them stand out and look quite three-dimensional. Shadows must be kept consistent. The direction, depth, and angle chosen for the shadow must continue through the whole alphabet to make words legible.

*fig. A.*

*fig. B.*

*fig. C.*

*fig. D.*

*fig. E.*

*fig. F.*

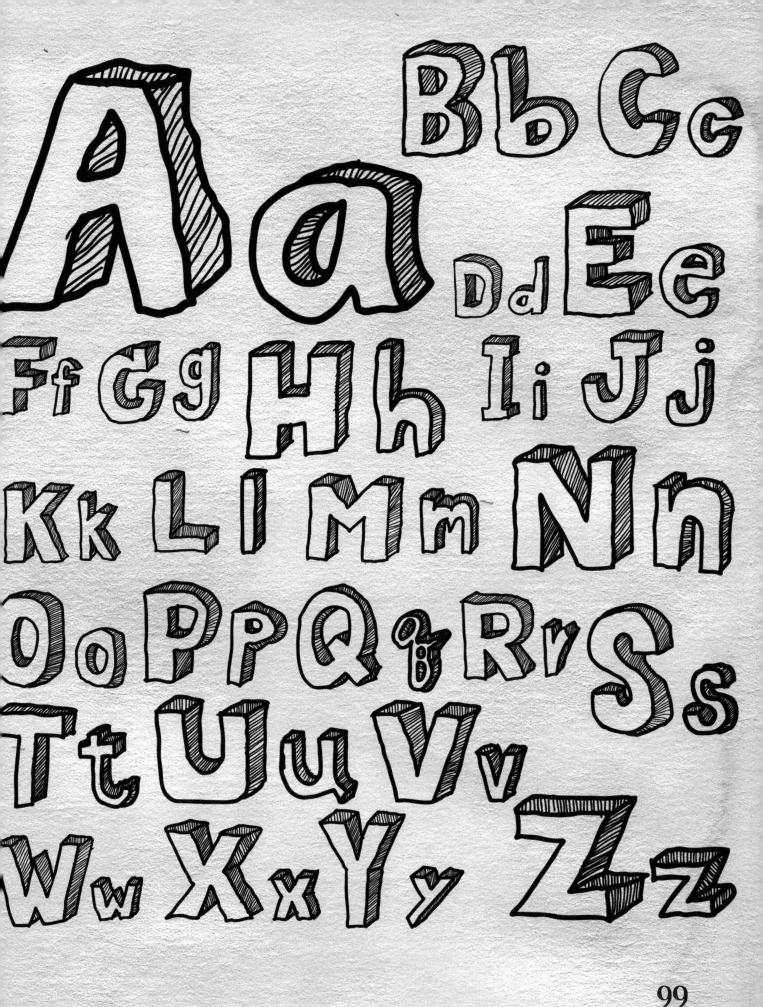

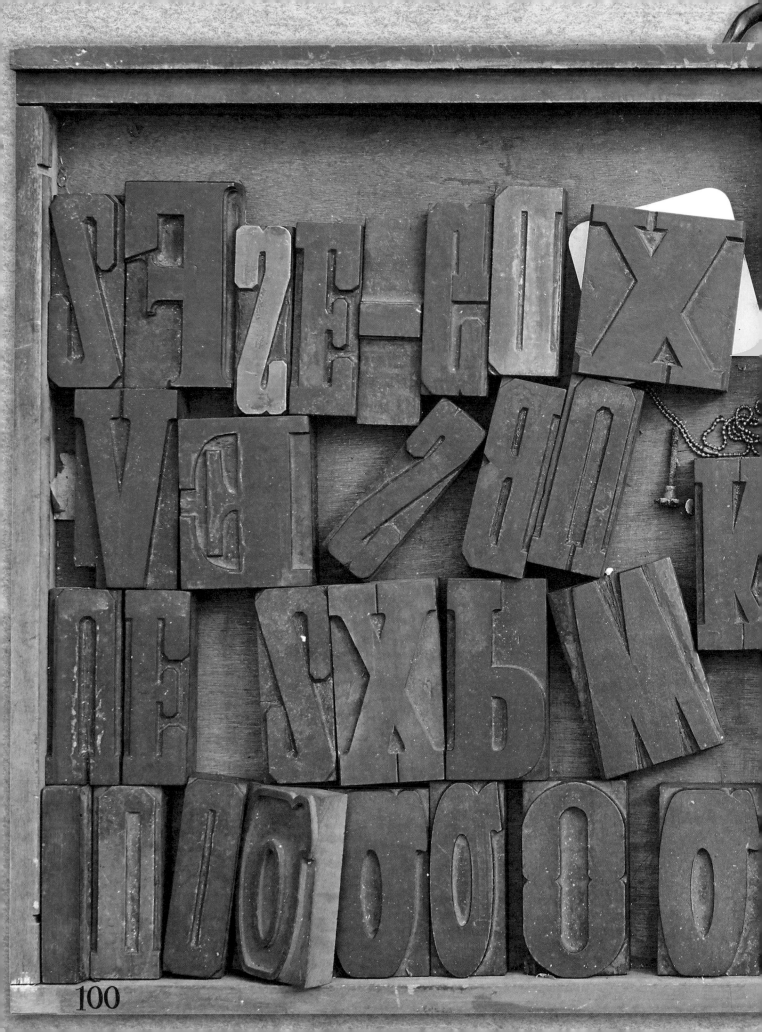

# CHAPTER VI
# PRINTING

# Relief printing

## Materials

- Lino cutting tools
- Lino
- Pencils
- Cartridge paper
- Water-based ink
- Wooden spoon
- Roller
- Scissors
- Plastic tray or glass sheet
- Felt-tip pen
- Non-slip matting
- Permanent marker pen

## Technique

**Lino** comes in different gauges of hardness. Easy-cut lino is softer to cut, and traditional linoleum will be harder.

**Tools** come in a wide range of shapes. Use non-slip matting under the lino when cutting. Always take care to cut away from your hand. Supervise children when using cutting tools.

**Ink** Water-washable relief printing ink prints well but also cleans up easily with soap and water. Inks will stay wet for a couple of hours. Prints can take two or three days to dry.

A hard rubber roller is essential. The wooden spoon is for burnishing the back of the print.

**W**ooden and metal blocks, traditionally used for relief printmaking, have a tactile handmade feel. However linoleum, made from cork and linseed oil and invented in the 1800s as a floor covering, is much cheaper and easier to work. The use of lino as a printmaking block became popular in the early 1900s with the artists Matisse and Picasso. Later, Edward Bawden designed linocut posters for the London Underground.

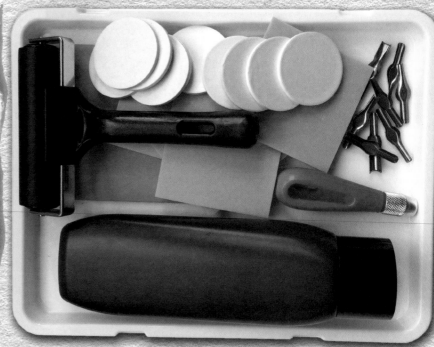

Linoleum block printing involves carving into the lino, then inking in with a roller so the image can then be printed.

# Carving and printing

## Technique

1. Draw around the lino shape on a piece of paper. (fig. A.)

2. Using a soft pencil draw a letter (as shown). Cut the square out. (fig. B.)

3. Place the square face down on the lino. Scribble over the back with a hard pencil to transfer the drawing onto the lino. (fig. C.)

4. Lift one corner to see if the design has transferred well. The letter will now be in reverse. (fig. D.)

5. Use a marker pen to color in the areas that you want to print. Keep lines thicker so they are easier to cut around. (fig. E.)

6. Place the lino on a non-slip mat and cut out the white areas. Always cut away from your other hand. (fig. F.)

7. Add ink to the tray or glass sheet. Spread it evenly across the surface with the roller. The ink should not be too thick. (fig. G.)

8. Run the roller over the linocut. Repeat once or twice until the lino is well covered with a thin layer of ink. If ink gets onto any of the cut away areas, wipe it off with a dry cloth. (fig. H.)

9. Place the paper on top of the inked block and hold. Using a circular motion, rub the back of the paper with the spoon to transfer the print. Carefully, peel the paper off the lino. Leave to dry for two to three days. (fig. I.)

*fig. A.*

*fig. B.*

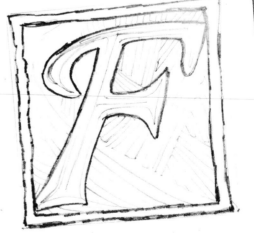

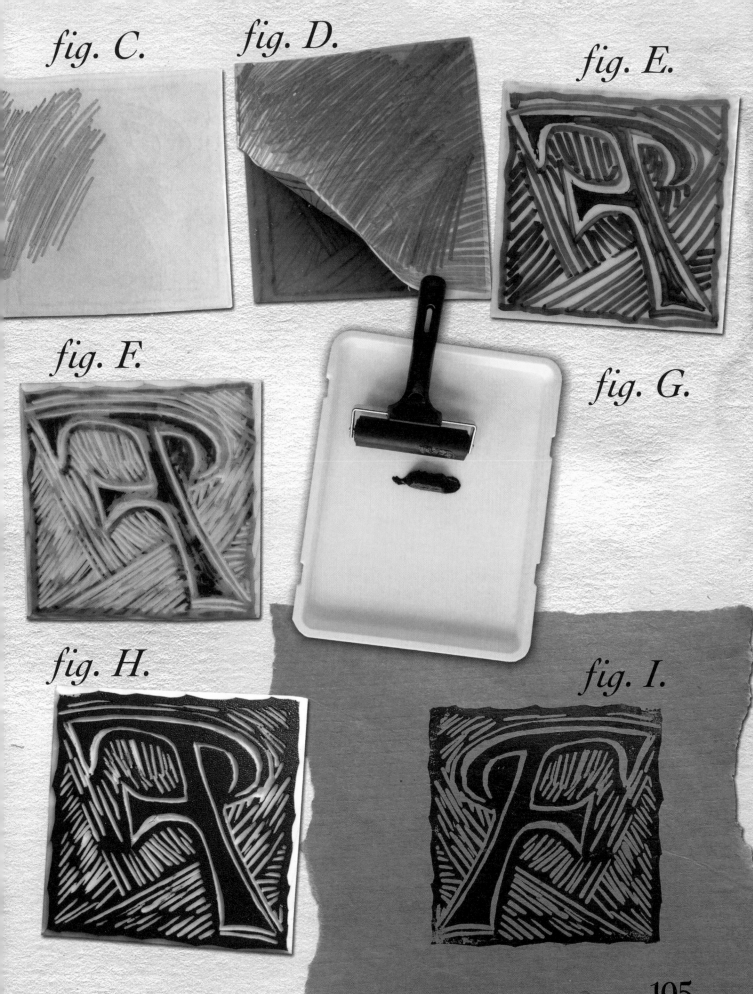

*fig. C.*

*fig. D.*

*fig. E.*

*fig. F.*

*fig. G.*

*fig. H.*

*fig. I.*

### Materials

- Card
- Old woodblock
- Pencil
- Glass sheet or plastic tray
- Water-based block-printing ink
- Rubber roller
- Wooden or plastic spoon

### Technique

To block print a greeting card: Cut the card size as required. The image must be printed on the right-hand side—the front of the card.

1. Choose a woodblock letter. (fig. A.)

2. Ink up the roller and slowly roll it across the woodblock. Repeat until the whole block is evenly covered with ink. (fig. B.)

3. Place the front of the card face down on top of the inked woodblock. Hold firmly and burnish the card using the back of the wooden spoon in a circular motion. (fig. C.)

4. Carefully lift the card off the woodblock. Leave to dry for two to three days. (fig. D.)

# Letterpress printing

**W**oodblock printing originated in China in AD 220 and was initially used for printing on silks and later on paper. When movable letter blocks were invented, words could be assembled to print as text on paper. Woodblock letters were carved in relief: each letter was formed by cutting away the "negative" space that shaped it to isolate the letterform on the printing surface.

*fig. A.*

*fig. B.*

*fig. C.*

*fig. D.*

The art of carving woodblocks, or "letterpress" blocks, is called "xylography." Carved in reverse, a woodblock prints a mirrored version of its surface design. The surface is inked with a roller, leaving the undercut "white" parts ink-free. Paper is then pressed against the block and burnished. Later printing presses transferred the ink onto paper by stamping.

## Materials

- Paper
- Old woodblocks
- Pencil
- Glass sheet or plastic tray
- Water-based block-printing ink
- Rubber roller
- Wooden spoon

## Technique

Printed letters make attractive fine-art prints. Inked up letterblocks are placed on a sheet. Lay paper on top of the inked letters. Carefully burnish the back of the paper with the wooden spoon. Peel back the paper to reveal beautiful printed letters.

# Letterpress

**B**y the 1980s, letterpress was no longer used for printing. Computers and self-publishing print and publish techniques were more efficient and had made the letterpress printing process obsolete.

Letterpress printing companies went out of business and their presses and type were sold off. Letterpress has undergone a revival as a craft to make fine art stationary as its traditional use for printing newspapers is no longer relevant.

The invention of the printing press in Europe in the 15th century meant that "woodcuts" (images engraved into woodblocks) were used to illustrate books. These were cut to the same depth as the carved type so that images and text could be printed together. Woodblock illustrations went out of fashion in the 17th century, but by the 19th century the German Expressionists reverted to this technique to create their stark and stylized woodcut prints. In the early 20th century, the artist and critic Roger Fry used woodcuts on decorative items and to illustrate books, most notably "12 Original Woodcuts" published by the Hogarth Press.

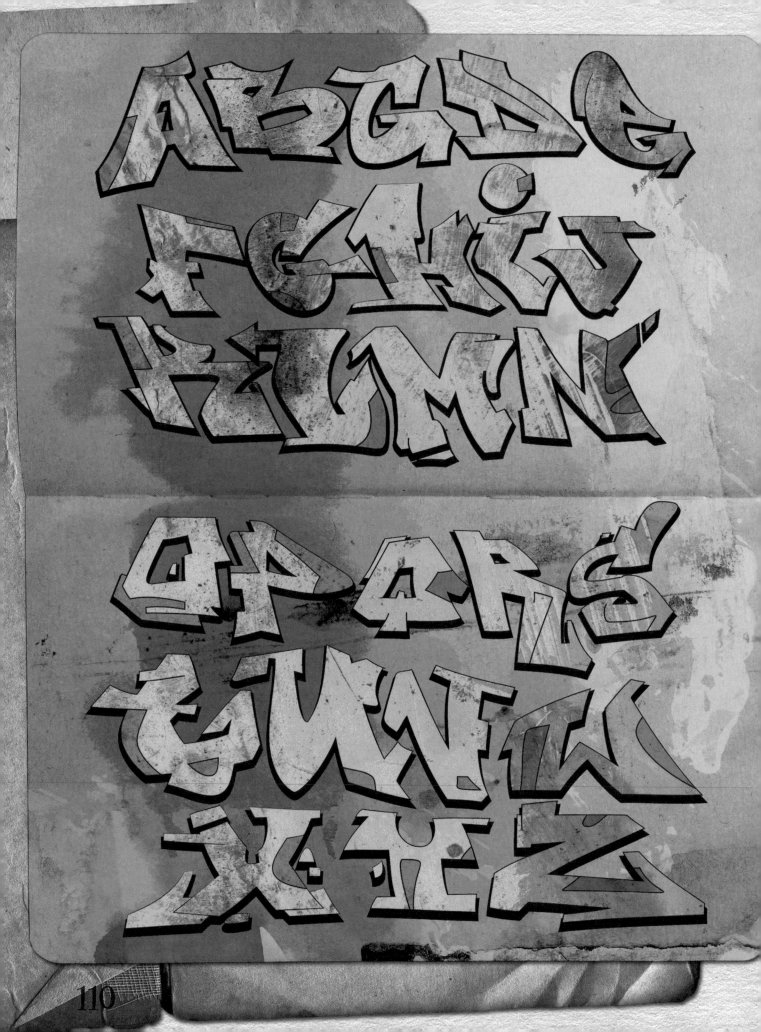

# CHAPTER VII

# INSPIRATION

АБВГДЕЁХЖЗИЙ

КЛМНОПРСТУФХ

ЦЧШЩЪЫЬЭЮЯ

$€£¥₩฿₹₽

<<1234567890>>

*@&/I№#=+−

!?%‰:;{}□□{}

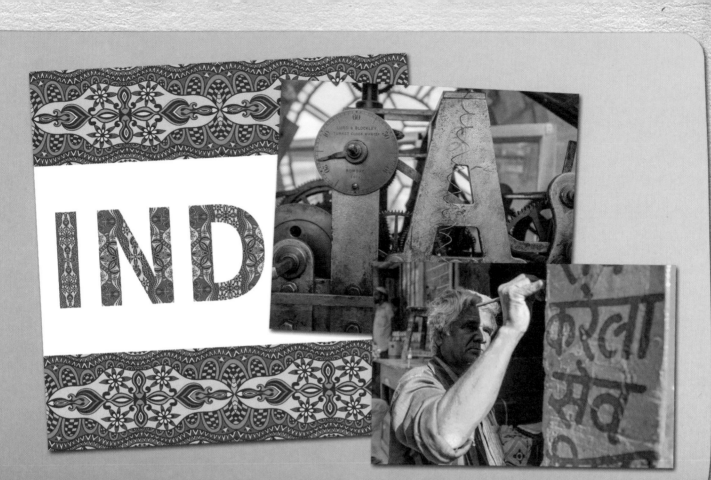

अ आ ड्ड ड्ड उ ऊ ऋ ॠ
ऌ ए ऐ ओ औ अं अः क
ख ग घ ङ च छ ज झ
ञ ट ठ ड ढ ण त थ
द ध न प फ ब भ म
य र ल व श ष स ह

ÀÁAAABBBBBCCCC.
DDDDÈÉEEFFFFF:
GGGGHHHHIIIIÌÍ«»
JJJJKKKKLLLLLMM
MMMNNNNNOOÒÓ()
PPPPQQQQRRRR
SSSSTTTTTUUÙÚ;
VVVVWWWWWXX
XXYYYYYZZZZ??!!-

àáaaabbbbbçcccc.
ddddèéeeeffffff$:
ggggghhhhhfiiiiiìí«»
fjjjjkkkkkflllmm€
mmmnnññooòó()
"ppppqqqqrrrrrr"
ssssstttttuuùú;¥
wwwwxxx£
xyyyyzzzz??!!-@

22222333334444455555566666
77777888889999998&&&&&&QQQQQQ
ZZZZZEEEEEERRRRRRTTTTTTYYYYYY
UUUUUUIIIIIIOOOOOOPPPPPPAAAAAA
SSSSSSDDDDDDFFFFFFGGGGGGHHHHHH
JJJJJJKKKKKKLLLLLLMMMMMMWWWWWW
XXXXXXCCCCCCVVVVVVBBBBBBNNNNNN
éééééééèèèèèèçççççÇàààààààqqqqqq(((((((
zzzzzzeeeeeerrrrrrttttttyyyyyy)))))))
uuuuuuiiiiiiooooooppppppllllll!!!!!!!
aaaaaassssssddddddffffffgggggg°°°°°°°
hhhhhhjjjjjjkkkkkkllllllmmmmmm
ùùùùùùwwwwwwxxxxxxccccccbbbbbb
nnnnnnòòòòòòvvvvvv^^^^^^,,,,,,;;;;;;::::::
========!!!!!!%%%%%%??????++++++
///--------///

D J

22222
777777
X

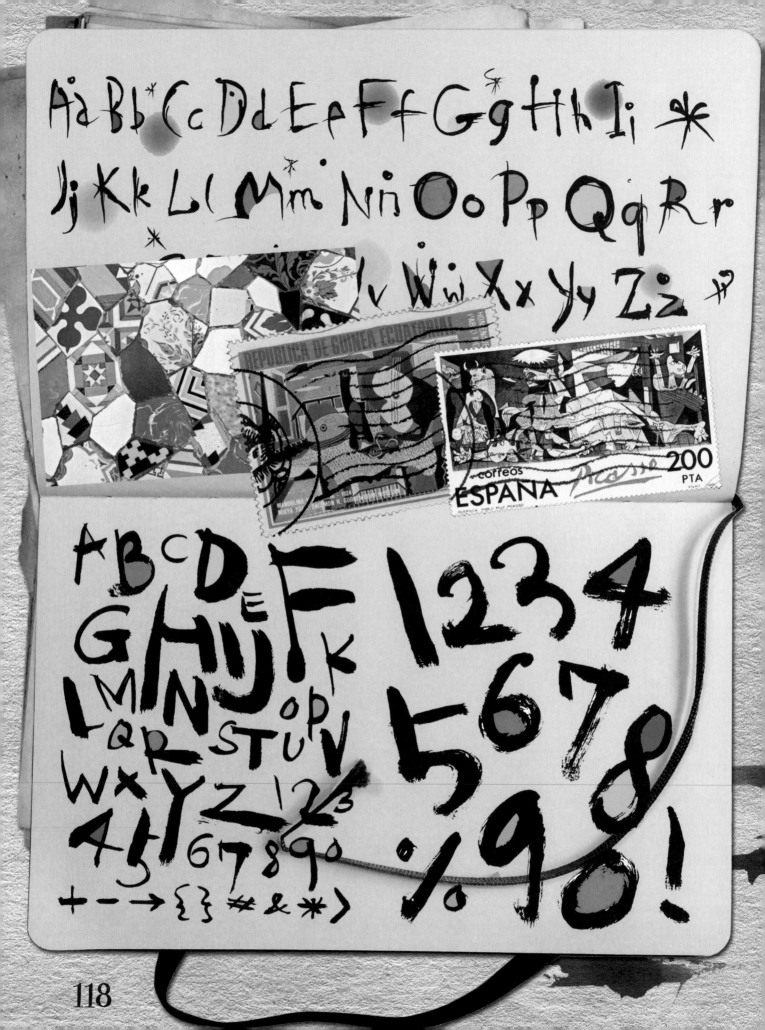

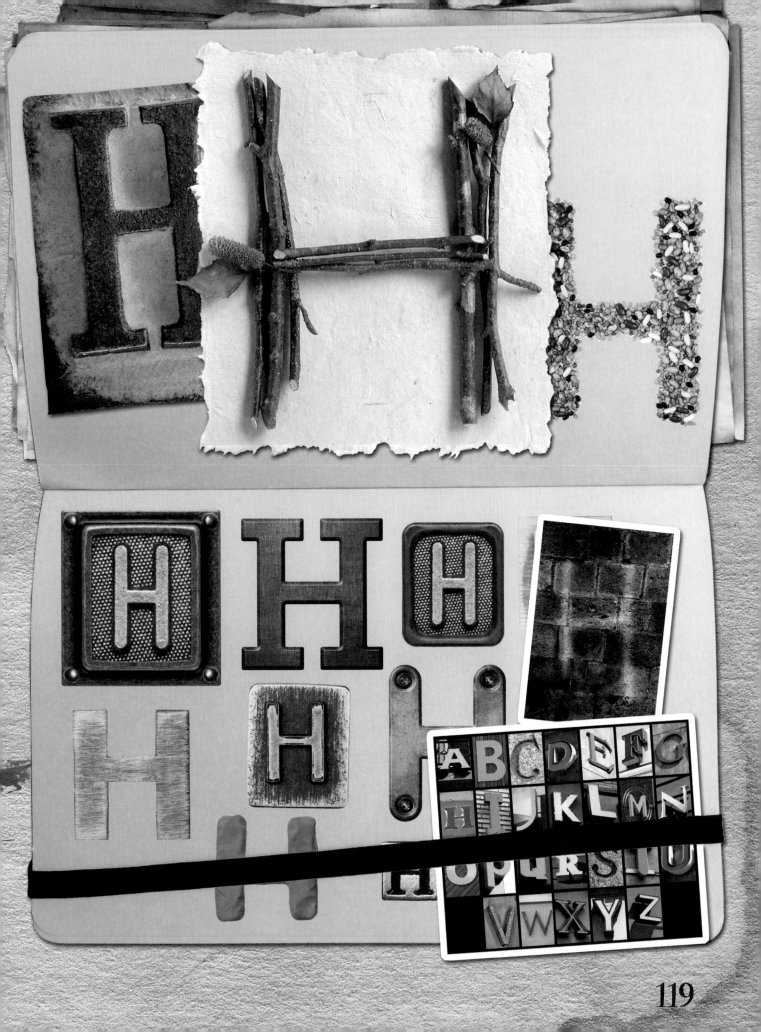

AAÀÁABBBBLLLMMMM
BCCCCCDDDNNNNOOÒÓ
DDEEEÈÉEFFOPPPPPQQQQ
FFFGGGGGHHQRRRRRSSS
HHHHIIIIIIIÌÍ JJWWWXX
JJJKKKKKKLL YYYYYZZ
SSTTTTTUUÚ XXX ZZZ
ÙUVVVVVVW :<><;:

ačiū
multumesc
kiitos  Danke
Grazie
谢谢  хвала  Gracias
salamat  Спасибо
teşekkür ederim  paldies
Tack
Asante  ευχαριστώ  Obrigado  Спасибі
תודה
dank u
謝謝  Tak
Dankie  terima kasih
Благодаря
ď'akujem
Thank you
Merci
dziękuję  Sağol  Děkuji  Дякуй
Hvala

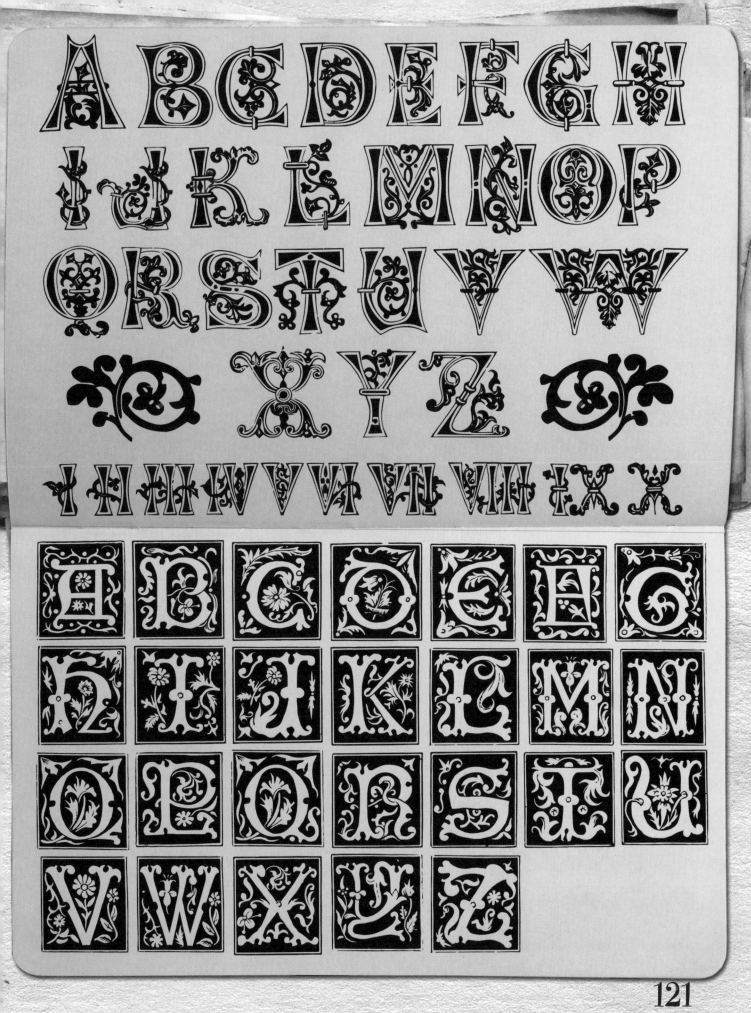

ABCDEFGHIJKLMN
OPQRSTUVWXYZ?!
abcdefghijklmnop
qrstuvwxyz€$£&%
1234567890@+-=

# Glossary

## A

**Alphabet** Standardized written or printed letters that represent basic significant sounds of a spoken language, used to write one or more languages. The Latin alphabet, originating from the ancient Greeks, is the most commonly used—many languages use variations of it. Most alphabets have letters composed of lines with the exception of Braille and Morse code.

## B

**Baroque** A style of architecture, painting, and sculpture. It originated in Europe in the late 16th century. By the 18th century, Baroque symmetry gave way to a more ornate, curving style.

**Board** Card in a wide range of colors and thicknesses. Used for model making, for mounting artwork, and as a firm backing material for artwork.

## C

**Cartridge paper** Good-quality white paper for general use. Available in different weights.

**Calligraphy** (see above) The art of writing letters with a dip pen, brush, or other writing implements.

**Collage** Derived from the French verb *coller* meaning "to stick." Collage is a technique where cloth, paper, or other materials are pasted onto a surface to create a mixed media assemblage.

**Construction lines** Lightly drawn lines used as a guide in the early stages of a drawing. Usually erased later.

## F

**Felt-tip pen** A pen with a felt nib containing quick-drying ink.

**Fixative** A thin varnish sprayed over drawings to prevent smudging.

**Font** In metal typesetting, a font is a particular size, weight, and style of typeface. Each font is a matched set of type, one piece (called a "sort") for each glyph. A typeface is a range of fonts that share an overall design.

## G

**Glyph** A symbol that represents a character in a written language.

**Graph paper** Paper printed with square and isometric grids in different scales. Used as guides for drawing and model making.

## K

**Kufic** An early angular form of Arabic script, traditionally used to write out the Koran. In the present day, the Koran is usually written in Naskhi, a more cursive script.

## L

**Layout paper** Thin white paper used for sketching out initial ideas.

**Light source** The direction of light on an object or drawing.

# M

**Mehndi** A henna paste used to draw linear designs on the hands and feet. Used for traditional celebrations like weddings.

# P

**Paper sizes** range between A0 and A6, the smallest. The most common size is A4. Each "A" size is half the preceding one: A4 is half the size of A3.

**Perspective** A method of drawing. Closer objects are shown larger than distant objects to create a feeling of depth.

# T

**Tracing paper** A semi-translucent paper. It can be used for making copies of drawings.

**Typeface** In typography, a typeface is a set of one or more fonts. A font is composed of "glyphs" of similar design, although each has a specific style, weight, width, and angle.

# V

**Vellum** Derived from the Latin word *vitulinum* meaning "made from calf." Parchment made from animal skin, used traditionally in the Middle Ages for manuscript illustration, illuminated calligraphy, and bookbinding.

# W

**Watercolor brushes** have soft, dense tufts to hold the water content. Made from animal hair or synthetic fibers in a range of styles and sizes.

**Watercolor paint** Water soluble paint, available in tubes or pans. Gives saturated rich color.

**Watercolor pencils** Colored pencils that combine concentrated extra-fine pigments with water solubility. Used with water or as dry pencil.

**Wet-on-dry** Painting technique using wet brush strokes on top of a dry watercolor wash to achieve sharp edges.

**Wet-on-wet** A painting technique that involves the application of wet paint to an already wet surface. The colors will bleed into one another, creating soft edges.

# X

**X-height** In a typeface, it denotes the distance between the baseline and the top of lowercase letters. X-height is used to define how high the lowercase letters are in comparison to the uppercase. It is the height of the letter x in a font and also u, v, w, and z.

# Index